ETERNAL PRAIRIE

Exploring Rural Cemeteries of the West

Text and photographs by R. Adams

FIFTH
HOUSE
PUBLISHERS

All images in this book were taken by the author with a Nikon F 35mm camera. The images on the following pages have been reprinted courtesy of the Provincial Archives of Alberta/Randy Adams Collection–95.87.
4 (bottom), 8, 14 (left), 18, 19, 21 (top), 38 (top), 22 (top and bottom), 23 (top and bottom), 24 (bottom), 26, 45 (top and bottom), 49, 57, 59, 75, 79, 85 (this image also appears on the back cover)

Front and back cover images by Randy Adams
Cover and interior design by Kunz+Associates, Calgary, Alberta

The publisher gratefully acknowledges the support of The Canada Council for the Arts and the Department of Canadian Heritage.

THE CANADA COUNCIL | LE CONSEIL DES ARTS
FOR THE ARTS | DU CANADA
SINCE 1957 | DEPUIS 1957

We acknowledge the financial support of the Government of Canada through the Book Publishing Industry Development Program for our publishing activities.

Printed in Canada

99 00 01 02 03 / 5 4 3 2 1

CANADIAN CATALOGUING IN PUBLICATION DATA

Adams, R. (Randy), 1951–
Eternal prairie

Includes index.
ISBN 1-894004-33-7

1. Sepulchral monuments—Prairie Provinces. 2. Epitaphs—Prairie Provinces. 3. Cemeteries—Prairie Provinces. 4. Funeral rites and ceremonies—Prairie Provinces—History. I. Title.

GT3213.A3P7 1999 929'.5'09712 C99-910660-0

Published in Canada by
Fifth House Ltd.
A Fitzhenry & Whiteside Company
#9 - 6125 11 St. SE
Calgary, Alberta
T2H 2L6

Published in the U.S. by Fitzhenry & Whiteside
121 Harvard Ave.
Suite 2
Allston, Massachusetts
02134

Contents

➤━┃━◆━━◇━━◆━┃━◅

This book is dedicated to Davey.
(David John King, 1966–1990)

>–⊢◆–•–O–•–⊢◆–⊣<

ACKNOWLEDGEMENTS

Eternal Prairie would not have been possible without the generous support of the Alberta Foundation for the Arts. Although the writing of this book received no direct funding, certain visual arts and writing grants over the past fifteen years allowed for much of the travel and photography. I would therefore like to express my appreciation to the jurors and arts professionals who saw merit in my work.

I would also like to thank the Alberta Historical Resources Foundation for the research grant that allowed me to photograph the cemeteries of rural Alberta, and the Alberta Provincial Archives for housing the collection that resulted from the project. Portions of the text have appeared in *NeWest Review*, *The Western Producer*, and *Rim*. A hardy thanks to the editors and staff of those publications, as well as to the people who published and edited the now defunct *Edmonton Bullet*. Thanks also to those people who helped support my photographic habit by purchasing prints and to those curators who have exhibited my work in public galleries.

Finally, a special thanks to the kind and generous rural folks who shared their stories, to Fifth House editor Charlene Dobmeier for believing in this book, and to my travel companions, who put up with more than I dare mention.

THE CANADIAN PRAIRIE PROVINCES

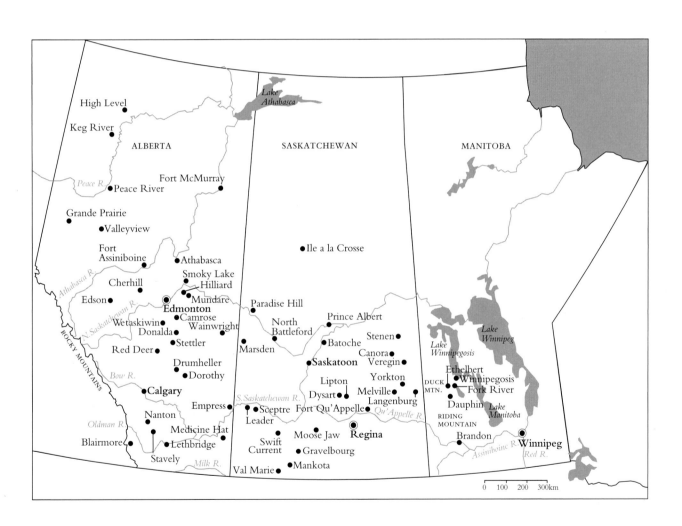

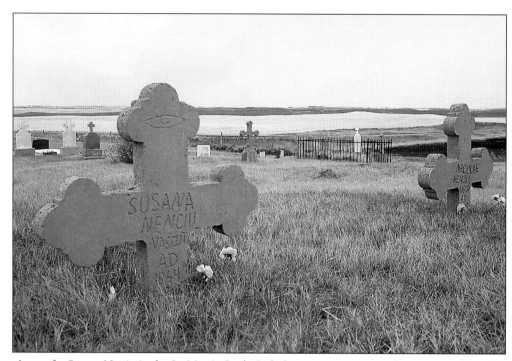

A cross for Susana Nenciu in the St. Mary's Greek Orthodox cemetery near Kayville, SK. A single eye has been scrawled into the cement marker. The eye is an ancient symbol with various meanings, including divine wisdom. It was also used to ward off evil spirits. Some cultures still place the symbol on amulets that hang in homes, shops, automobiles, and boats.

INTRODUCTION

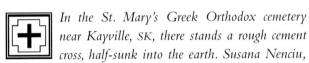 *In the St. Mary's Greek Orthodox cemetery near Kayville, SK, there stands a rough cement cross, half-sunk into the earth. Susana Nenciu, born 1864; date died buried too deep to read. And scrawled at the centre of the cross, as if looking back out upon the world, is a saucer-shaped eye. I still remember the exact moment, kneeling on the ground, focusing my camera on the grave marker, and thinking about how that symbol—a single eye—was more ancient than history. I knelt there a long time, transfixed by its simplicity. The fall sky held high white clouds, and a chill wind blew grey showers along the horizon. Strips of farmland stretched into the distance— some ploughed-black patches and still green pastures. Susana's cross was rooted deep in the earth, and the earth circled round all sides back to me. I was struck by the oddest sensation of being watched.*

It wasn't an unexpected sensation. Many cemeteries evoke the same feeling. It could be simply a heightened awareness of the corporeal nature of life—standing quietly with the dead, and knowing beyond a shadow of doubt that we all cross the same threshold.

Whatever it is, after peering through my camera lens at literally thousands of grave markers, I have come to feel perfectly at ease with the curious phenomenon. There is a certain peace residing in cemeteries that can't be experienced anywhere else.

No matter whether a person is buried or cremated— the body placed in a coffin or the remains stored in a cinerary urn—the essential elements of our flesh and bone have to be consigned somewhere. For many people, religion or custom dictates that they be interred in the churchyard or community cemetery. But others request that their ashes be spread over a particular landscape, into the sea, a lake, or a river, or dug into the soil of the family garden—usually a place where the person has felt at peace, performed a special feat, or overcome some obstacle. But, regardless of what a person decides to do with his or her mortal remains, most people find a certain comfort in envisioning a landscape they will forever be a part of.

And it's the landscape that lends prairie cemeteries their uniqueness. Maybe there's a creek meandering

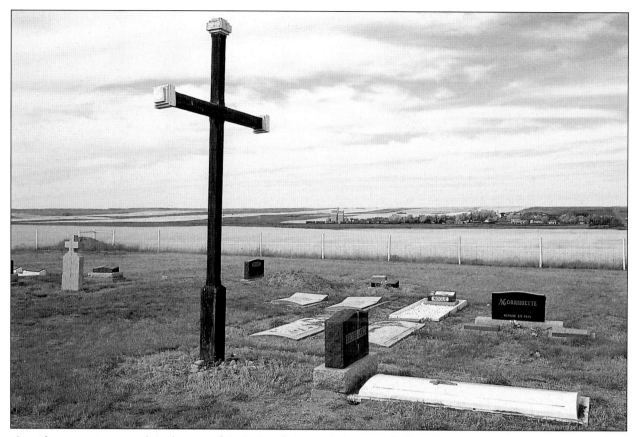

A wooden cemetery cross stands in the centre of the St. Jean de Baptiste cemetery overlooking the small southern Saskatchewan community of Ferland. The three wood blocks at each end of the cross represent the Trinity.

below the fence line, or the graveyard sits on a hill from where you can see all the roads leading out of town—one of them inevitably called Railway Avenue. Or maybe there's an old settlement nearby with scattered buildings that were once a hamlet: two churches and a smithy, a general store, a grain elevator unused for twenty years. Each cemetery fits within its own landscape and changes with the cycle of the seasons: perennials blooming bright each spring; summer heat with the smell of new-mown grass and warm earth; late fall after harvest, stubble fields wild with geese; winter, when snow drifts high against the grave markers; then spring again, when the snow melts first from off the granite slabs.

There are usually animals nearby: antelope, deer, cattle, woodpeckers, always gophers and crows. Now and then you catch sight of a coyote, appearing suddenly, then veering sideways and vanishing, like a speck of the land itself. Swallows and blackbirds flit in and

around the graves. Sometimes there are animals displayed on the grave markers—eagles, lambs, cattle, horses—each representing some aspect of life; like the

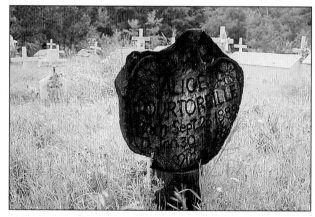

Alice Courtoreille's (1889–1978) hand-carved grave marker, at the Child Lake Indian Reserve near High Level, AB, is particularly interesting. The use of natural wood for the marker exemplifies her love of the land. The dove, flower, and heart motifs reflect a Christian influence.

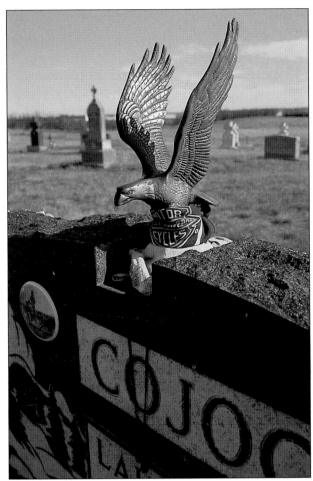

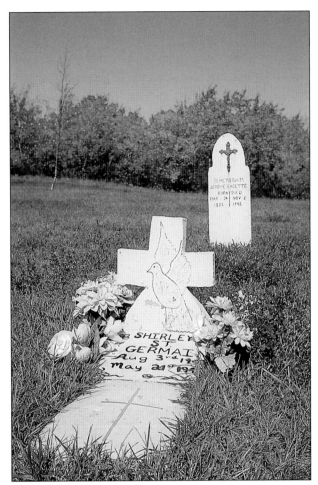

The eagle adorning the top of this gravestone in a cemetery near Gravelbourg, SK, imparts that Lawrence Cojocar obviously loved his ride, or motorcycle (most particularly his Harley). But the eagle also has a rich symbolic history. Eagles were sacred to Zeus, and Roman legions used to march under standards bearing the eagle. With the advent of Christianity, the cross replaced the eagle. Since the eagle soars upward, it became a symbol for Christ's Ascension. ("But those who hope in the Lord will renew their strength. They will soar on wings like eagles." Isaiah 40:31)

This hand-painted blue dove is for Shirley St. Germain (1947–1948), buried in the St. Laurent Roman Catholic cemetery (directly across the South Saskatchewan River from Batoche). The dove is one of the earliest of Christian symbols. It represents the Holy Ghost. It is also an attribute of Peace personified and Chastity, making it an appropriate symbol to mark the graves of small children. In ancient times, doves were sacred to several mother-goddesses of the Near East. In Greek myth, they were sacred to Aphrodite and Zeus.

dove, which represents not a bird, but flight, the flying above. The very sun in the sky is echoed by iron rays, or haloes. Even the moon is brought to earth in the form of a crescent. So much life in the midst of death.

For reasons hard to explain, I have spent many years photographing the cemeteries of western Canada. When asked why, I have no slick answer: I did not set out, initially, to pursue such a study. Nonetheless, I have travelled thousands of miles of highways and gravel roads, mud and dirt trails—Fort Assiniboine to Val Marie, Hinton to Dauphin, each year a different route. The variety of cemeteries seems endless: from the spirit houses in the northern Alberta Métis community of Paddle Prairie to the elaborate iron crosses in the German Catholic cemeteries of Saskatchewan; from the stonework of a grave monument in the Polish Catholic cemetery in the small Alberta town of Mundare to the crude cement crosses fashioned by a local craftsman in a graveyard at the foot of Riding Mountain, near Dauphin, MB. I've shot countless frames of film and written reams of journal entries. I've discovered that even the most skeptical of people—if I stand about

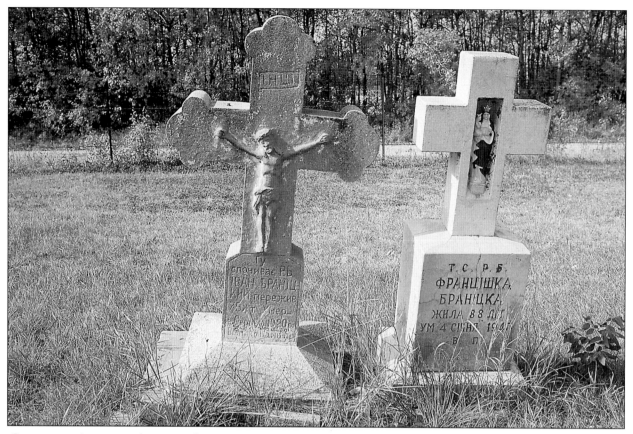

Cement crosses in a graveyard near Dauphin, MB. An interesting rendition of his and hers.

A "spirit house" in the Paddle Prairie Métis settlement in northern Alberta. Some spirit houses are decorated with ornamental cutwork and lathe-turned wooden posts. Although the spirit houses are a direct result of commercial-minded white folks trying to find new markets for their products (lumber and hardware), the constructions still reflect the ancient Native custom of placing the dead on raised platforms or high in the boughs of trees.

shuffling my feet long enough—will tell me about their favourite cemetery, or where their relatives are buried. On a good day, I get an earful of local history.

I recall one summer day, standing alongside a dusty road outside the Richmond Park Holy Ghost cemetery, near Athabasca, AB, talking with a local farmer by the name of William Chursch.

"We don't bother with gravediggers here," he said. "We get together and dig the graves ourselves. Bought mine years ago for twenty dollars." He was pointing out his plot when his wife came by in a pick-up truck.

"What's the conference?" she asked, peeking her head out the window.

William Chursch just lifted the brim of his cap and said, "He's taking pictures of where you're going to bury me." His wife drove off faster than she'd arrived.

William shook his head. "Not everyone thinks I'm funny, I guess. But I figure you gotta keep things in perspective."

A fieldstone tomb in the Polish Catholic cemetery in Mundare, AB, built by a skilled stonemason who used a temple design very common in Eastern Europe.

Another time, a caretaker at a cemetery told me that "a few years back, we hit this big rock and had to blast, the hearse showed up with the body and everyone pulls in behind, almost the whole town, but we weren't nearly ready, so they all had to wait in their cars and watch as we blew up the grave." At another cemetery I heard the story about a stray cow, how it broke through the fence and went wandering over the graves. "Yeah, funny thing. The slab looks just like cement unless you get real close. I'll bet you Marini would've laughed, though. It was his cow that broke through the fibreglass. Looked just like it was kneeling on his grave."

I have discovered that the farther you travel from the cities, the more individually expressive are the markers. In Alberta's Stavely cemetery, there's a ceramic figure in Victorian dress at the head of a grave, with the epitaph: *Though she lived in times of strife, she was a good mother, a wonderful wife. So if there is another life, God bless her.*

This unique marker is found in the Stavely cemetery in southern Alberta.

Near Hondo, AB, someone has constructed a miniature replica of a log house to honour the memory of Virginia Sand—mother. One of the oddest things I ever found was in the Chechow Catholic cemetery near Preeceville, SK—a crucifix in a pried-open

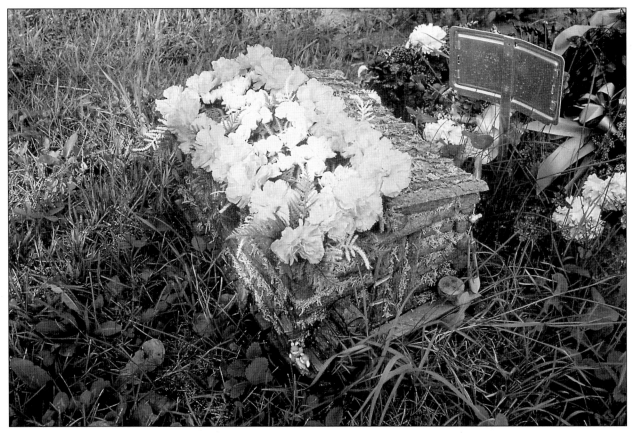

This small replica of a log house in the Roman Catholic cemetery of Hondo, AB, was built for Virginia Sand (1918–1993).

sardine tin. And, in the Onoway Baptist cemetery, a few kilometres west of Edmonton, there's a wooden cross covered in red shag carpet.

I've learned to spot the unusual at a distance, and sometimes I just idle past. But other times I get a gut feeling about a cemetery, a sense that there's something special there. Most of the relic grave markers have fallen, rotted, or crumbled long ago. But a few survive, altered by the sun, the wind, and long winters— having become caricatures of the very lives they commemorate. But modern markers, too, can be uniquely expressive. In the Union cemetery near Warburg, AB, Brent Ruff, a young hockey player who was killed in a tragic bus accident, has a modern granite marker in the shape of a hockey player. Sometimes monument makers are asked to etch particular images onto the markers—horses, cattle, trucks, tractors, grain elevators—and all of these memorial images are distinctly representative of the Canadian West.

Whether marked by an ornate monument or merely a simple cross, each gravesite is a place of memory. Some people return often, bringing fresh flowers or some other personal offering; or maybe they haven't been back for years and the place is overgrown in brush. Others drive halfway across the country to visit the grave of a distant relative, hoping to make some connection with their roots. Regardless of why one might visit a cemetery, memory remains at the heart of the matter. But not only do cemeteries give rise to personal memories, they connect us to a thread of common beliefs that stretch back to a time before antiquity. Even a perfect stranger can stand before a grave marker and imagine something of the person buried in that particular patch of earth.

I remember standing in a cemetery on the east face of a gentle slope, just off Highway 18 between Mankota and McCord, in southern Saskatchewan. The lowering sun brushed across the land with a Midas touch,

Brent Ruff (1970–1986) has a granite marker shaped like a hockey player in the Union cemetery near Warburg, AB. Brent, a sixteen-year-old hockey player, was killed in a tragic bus accident.

transforming the tawny fall colours into gold. The air was pungent with dry earth and sage. I sat back on my haunches and propped my elbows on my knees, focusing my old Nikon camera on a small stone marker. Although it was merely a cylindrically shaped piece of sandstone poking upright from the ground—blotched here and there with an orange-coloured lichen—someone had etched a border on the face of it, and then hand-lettered a name. No dates, no epitaph. Just "T.J. Wyatt," each black letter shaped with care.

I thought about all the expensive modern markers found in meticulously trimmed cemeteries, many repeating tried and true epitaphs. And I knew that not one of them could give rise to the feelings evoked by T.J. Wyatt's simple shard of sandstone. I couldn't help but imagine the exact moment—a moment isolated in time—when someone placed T.J.'s small marker upright over the grave. Although it was a mere fragment, imperceptible from the passing road, for someone, it was as entire as the life it represented. The practice of carving on rough stone is one of the most ancient of funerary customs, and so T.J.'s sandstone marker also stands as an expression of universal traditions, transcending locations, time, and pedigree—a true prairie hybrid.

If I had to choose a place where the journeys you will read about in this book began, it would be on my grandmother's farm, a quarter section of land eight kilometres (5 mi.) east of Leduc, AB. It was homesteaded by my maternal great-grandfather,

Colin Lennie, son of William Lennie, a blacksmith at Fort Edmonton as early as 1865. My grandmother was raised on the farm but, after marrying a CNR foreman, spent the rest of her life in Edmonton. Still, she managed to keep the old homestead and arranged for the flats to be sharecropped by a local farmer. There were several relic buildings on the top of the north hill, including a plank barn, a tiny one-room cabin, a shed, and a small stable. When I was a boy, my family drove to the farm for Sunday picnics, and every year in late summer and early fall we'd go berry picking. In winter we tobogganed down the hill. Afterwards, my grandmother made hot chocolate on the old wood stove in the cabin.

The barn sat on the crest of a hillside with a loft-window view down the valley to a long and narrow lake. I would clamber up the rickety ladder and sit at the window watching high white clouds coast overhead, shadow-dappling the hillside. Sometimes it seemed as if the barn was moving, and I'd imagine it was a ship sailing on the seas. If I sat still and silent long enough, swallows and doves would fly in and out of the barn. The world seemed so very wide, full of possibilities and mystery.

As the years passed, I often visited the farm. It was a place of refuge. A place to sit on the hilltop and watch hawks hunt over the field, a place to clear a patch of snow from the frozen creek and skate under a clear blue sky. In summer you could watch the beavers in the pond down past the potato patch, which my stepfather planted every year. I remember asking my grandmother about her life on the farm, and she'd tell stories about growing up in a large family. About riding in a horse-drawn sleigh to school in the winter. About how her father played the organ at country dances. What she didn't mention was that her grandfather, William Lennie, had been married to Annabella Fraser, a Métis daughter of Colin Fraser, HBC governor George Simpson's bagpiper. Nor did she speak of her mother, Clara Grant, an illegitimate daughter of HBC trader Johnny Grant and a Métis woman named Lily. My grandmother was born at the turn of the century, a mere sixteen years after the Riel Rebellion, and prejudice against First Nations and Métis people was at its height. She thought that she was protecting her family.

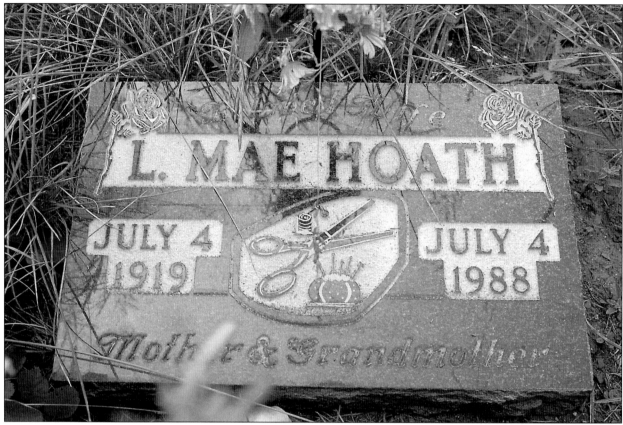

L. Mae Hoath (1919–1988) lies in the Heatherdown United Church cemetery near Onoway, AB. She is remembered as a mother and a grandmother and appears to have been a skilled tailor. The marker mimics the ancient tradition of burying people with the tools of their trade.

I can't remember any single event that got me travelling, but by the time I was nineteen I was on the road. During the decade when many of my friends were in university, learning one trade or another, or establishing businesses, I was rambling from landscape to landscape, never settling anywhere for long. I wandered up and down the spine of North America, working in the orchards of British Columbia, on farms and ranches in Alberta, and a gemstone mine in the Mojave Desert. I learned an assortment of skills. How to catch chickens in a dark barn—gathering four to a hand, their hard scaly legs like pencils stiff between your fingers, the squawking, the feathers and dust, and the stench of ammonia and fear. How to tighten barbed wire with only a claw hammer— hooking a barb into the claw and twisting the wire tight around the neck of the hammerhead. How to drill a hole and pack just the right amount of plastic

explosive to blow a vein of gemstone from off the wall of an open pit. How to prune a fruit tree by imagining the spokes of a wheel. How to turn a herd of spooked cattle through a narrow opening in a fence. How to swath a field. How to urge the last breath of life from cranky old machinery.

Eventually, I moved back to the city and turned my hands to other things. But my decade of itinerant work influenced all attempts at customary or steady employment. So I decided to become a writer and a photographer—occupations that inevitably led me back into the countryside, this time with notebooks and cameras. Maybe I was trying to reconnect with those feelings of mystery and possibility felt as a young boy sitting at the loft window. But I also believe that my curious wanderings were prompted partly by a desire to see beyond the veil of secrecy that my grandmother had drawn over the family's heritage—a

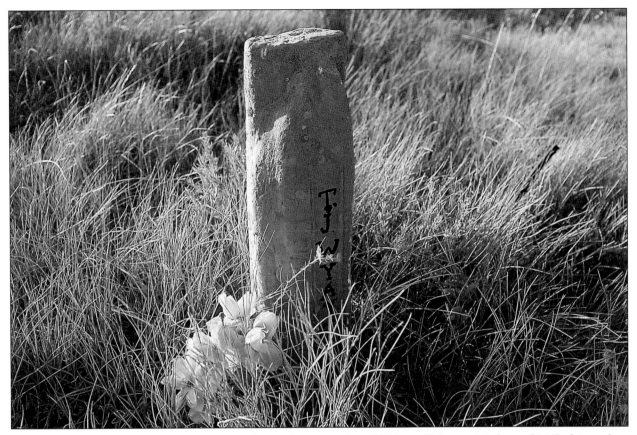

A shard of sandstone for T.J. Wyatt in the Big Beaver Community cemetery, just off Highway 18 between Mankota and McCord, in southern Saskatchewan.

searching for where I fit within the vast landscape that I call home. And the memories of those people whom I worked for and with—who faced each task with unflinching spirit and dogged determination— enabled me to continue documenting rural cemeteries, even when there seemed no good reason to do so.

To understand the prairies, you have to leave the main highways. And so *Eternal Prairie* is presented as a series of journeys, following the maze of secondary highways, blacktops, and back roads, through small towns with their names still emblazoned on grain elevators, and down dusty trails past relic homesteads, old settlement corners, country churches, and cemeteries. For the purpose of this book, the prairies are defined by certain borders—in the west, the Rocky Mountains; in the north, the forests; Lake Manitoba defines the eastern edge; and the southern border is drawn along the forty-ninth parallel. Although, having now defined the limits, I have to admit that some of the places are beyond the borders—in mountains of the Crowsnest, in the land of the *grande prairie*, or farther north into the forests—but these places too were part of the great migration from the Old World. They are all part of the same story. Like the crude eye scrawled on Susana Nenciu's cement cross, the cemeteries of western Canada contain shapes and symbols that have been in evolution for millennia, connecting us all to the same long but frayed thread of memory.

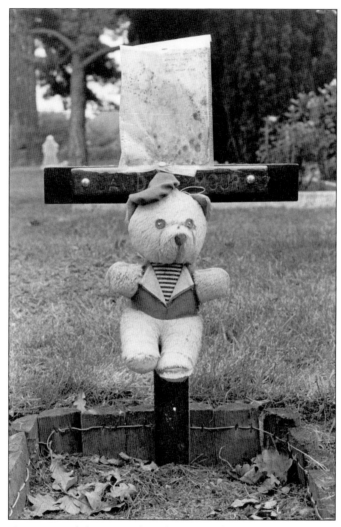

One section of the graveyard in the municipal cemetery in Colchester, England, is reserved for children. The practice of using playthings to mark the gravesites of children is an ancient custom dating back to Neolithic times.

TIMELESS TRADITIONS

If you take a map of the world and cut a piece of paper to match the geographical region of the Canadian prairies, and then place that small piece of paper over Europe, it stretches in the north from Paris to Warsaw, and in the south from Barcelona to Beograd. Is it any wonder, then, that the vast landscape of the prairies has been able to accommodate so many cultures? One community cemetery alone can contain a wildly assorted collection of names—Scottish, Ukrainian, Russian, German, Dutch, Hungarian, French, Italian, Arabic, Jewish, Chinese, Scandinavian, Persian. (The list is expressive, not exhaustive.) And each nationality has contributed some unique element of its culture to the cumulative funerary art of the prairies, creating a mosaic of the wider world. But, because so many politicians, religious groups, and business enterprises had particular agendas for settling the prairies, the cultural mosaic is rather abstract, and true to prairie form—an as-you-build-it.

My study of prairie cemeteries and funerary customs has given me a unique opportunity to fathom the indomitable spirit of enterprise and pursuit of the "good dream" exemplified by prairie pioneers. I have come to better understand this place I call home—the historical circumstances that have shaped it and continue to transform it. I've shot countless frames of film and jotted pages of journal entries. I've even gone so far as to spend almost a year wandering through

The use of small animal figures to mark the graves of children is common in many countries. Marlena Dawn Johnson lived for less than a month in the winter of 1979. Her grave is in Stavely, AB.

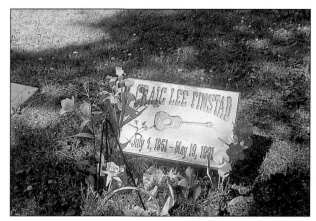

This handmade grave marker in Edson's Glenwood cemetery, AB, suggests that Craig Lee Finstad (1951–1991) was fond of playing guitar.

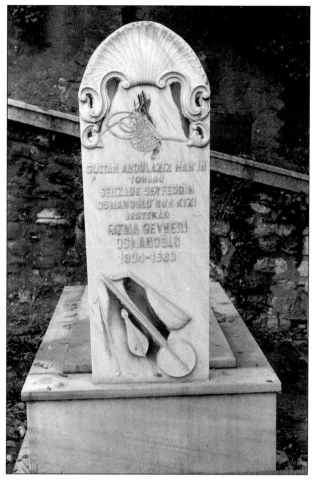

The marker for Fatma Gevheri Osmanoglu (1904–1980) of Istanbul stands in the cemetery dedicated to Sultan Mahamud II. Fatma was obviously a musician.

cemeteries in Europe and necropolises in Asia Minor. There I discovered first hand what I had previously only read about in history books—that what I was seeing on the Canadian prairies had its beginnings in antiquity. What we know of human history and the beliefs of ancient civilizations has, for the most part, been determined through the survival of tombs, sarcophagi, and burial mounds. Funerary artifacts are about all that's left of many ancient civilizations, and the study of such artifacts has revealed what people throughout the ages have treasured and feared. It seems that almost everyone wants to be remembered for having passed through this world.

No one knows for certain when humans first began the practice of burying their dead, and each civilization seems to have used different methods at different stages of cultural development. For example, in Çatal Hüyük ("fork mound"), a Stone Age settlement nine thousand years old discovered near the Turkish city of Konya on the Anatolian plateau, evidence suggests that the bones of the dead were once interred within the actual dwelling places of the living. In Europe and parts of Asia, it appears that cremation was also practised first in the Neolithic period, and that it was sometimes communal. Some cultures came to fear the dead, and bodies were buried beyond the boundaries of human habitation. Heavy slabs of stone were placed over the gravesites to keep the spirits of the dead from rising up to trouble the living. This developed into the custom of marking a gravesite with an upright stone slab (stele) or column decorated with inscriptions, figures, or symbols representing plants and animals.

Many of western society's beliefs and customs regarding death and burial were filtered through the ancient Greeks, who, at various times during their long history, used both interment and cremation. The word cemetery derives from the Greek *koimterion,* meaning "to lie down and rest," and many epitaphs echo this original meaning: *Rest in Peace, Resting in God's Garden, At Rest with Jesus, Resting Where No Shadows Fall.* In the Roman world, at the threshold of the Christian era, it was unlawful to bury the dead near the living. Tombs were therefore situated on either side of highways leading out of the cities, where

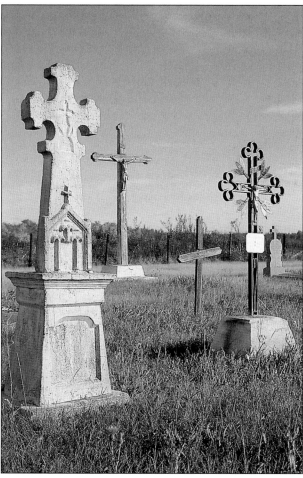

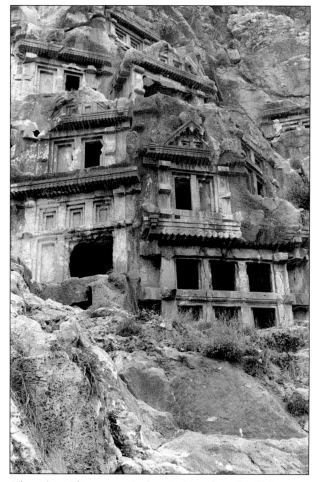

This grave marker in a Roman Catholic cemetery near Fish Creek, SK, reveals many interesting influences. The cross has trefoil ends. The cross design set at the centre is a variation of the Cross and Orb, or Triumphant Cross, which signifies Christ's victory over death. Most unique is the motif of an arch situated where the bottom of the cross rests on the base. This arch motif predates Christianity by several thousand years. The symbols inside the arch are shaped like palm trees, which represent Jesus' triumphal entry into Jerusalem.

The arch motif is apparent in these Lycian rock tombs of Myra, near the Turkish town of Demre. In 60, St. Paul, on his way to Rome, changed ships at Myra. Near the tombs is the famous church of St. Nicholas of Myra. Famous in his own time for certain miracles, he became patron saint of Greece and Russia, and also of children, sailors, merchants, and scholars.

monuments were erected to memorialize nobles or heroes. Evidence suggests that poor people and slaves were buried unceremoniously in dumps outside of town. But, according to practices originating in certain Roman colonies, most especially those in Africa, Christian martyrs were buried in necropolises just outside the city walls. Basilicas were then built over the burial sites and tended by monks. It wasn't long before people decided that they wanted to be buried close to these tombs, in order to be associated with the martyrs through a proximity to the sacred

structures. The city suburbs eventually sprawled into the countryside and encircled the tombs. Thus the abbey with its cemetery evolved into a model used predominately by western societies until the eighteenth century—the church and cemetery. This model lasted until the nineteenth century when, during the Agrarian and Industrial Revolutions, the European population shifted to the towns and cities. Spacious gardenlike cemeteries then replaced overcrowded churchyards.

The most popular marker designs in prairie cemeteries are based on those developed during England's

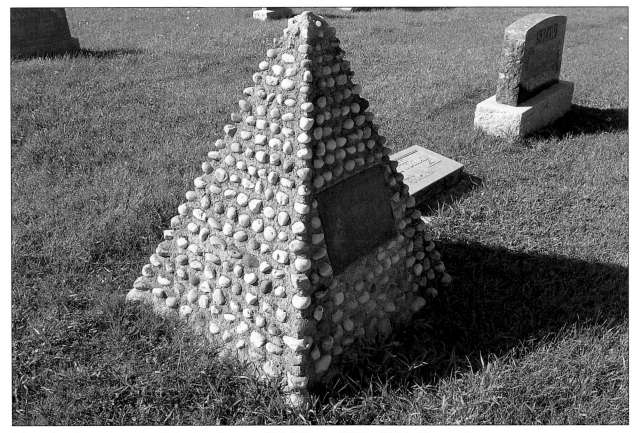

This replica of an ancient pyramid sits above the grave of Ethel Skinner (1890–1934) in Nanton, AB.

Victorian Age, a time when there was a heightened interest in archaeology and classical ruins. Thus the funerary architecture of the ancient world influenced European funerary art. The Lycian tombs at Xanthus (in what is now Mediterranean Turkey) are a good example. The tomb of Payava at Xanthus (fourth century BC) has a shape reminiscent of later Gothic tombs. Reduce the scale, and the shape of many modern markers becomes obvious.

And there's plenty of other evidence of these ancient influences—some of it uniquely *prairie*. In the community cemetery of the small Alberta town of Nanton, Ethel Skinner (1890–1934) has a 2.5-metre-high (4-ft.) cement pyramid over her grave. There is no mistaking the shape. Whoever fashioned the marker fully intended it to be a miniature replica of an ancient pyramid, going so far as to embed dozens of rows of small rocks, mimicking the rows of stone blocks that form an Egyptian pyramid.

Another interesting example of adapting an ancient shape can be found in the Bowmanville cemetery outside of Carmangay, AB, where Bell (no first name or dates) has a stone obelisk over his (or her) grave.

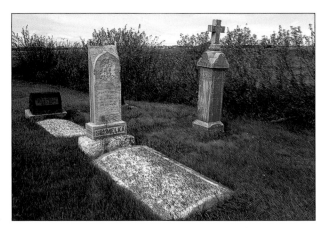

Many markers in prairie cemeteries reflect nostalgia for the Victorian Age. Monuments and markers during that period were often modelled after the tombs of ancient Greece, Asia Minor, and Egypt.

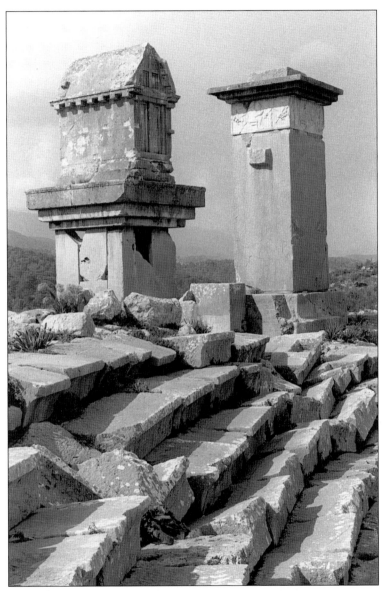

Two tombs set at the upper edge of the theatre in Xanthus, an ancient Lycian city on the south coast of Turkey. The grave in the foreground is from the third century BC, with a sarcophagus placed on top of a stunted pillar tomb. The top chamber of the other pillar tomb was once marble, decorated with fine reliefs, but it was removed by a British archaeologist and taken to the British Museum, where it can be seen in the Xanthus room. Reduce the scale of these tombs, and the shape of many modern markers becomes obvious.

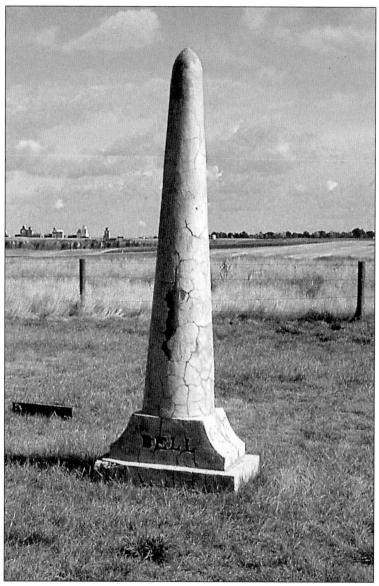

This grave in Alberta's Bowmanville cemetery features a stone obelisk—a shape that became popular during Victorian times.

Like pyramids, obelisks were associated with the worship of the sun. Although not funerary in origin, the obelisk shape also became popular during Victorian times. One particularly remarkable example of obelisk design sits atop the gravesite of Ivan and Anna Werbitski in the St. Albans cemetery in east central Alberta. The monument is entirely handmade and meticulously formed from sheet metal. Not only does the design reflect ancient traditions, but small plaster mushrooms have been placed at each corner of

The monument above the grave of Ivan and Anna Werbitski in the St. Albans, AB,
cemetery is entirely handmade. Small plaster mushrooms can be seen at the base.

the cement base, harkening back to prehistoric times. Because plants feed upon dead and putrefying matter, they have always been associated with funerary art. In some civilizations, fungi, especially mushrooms, have held a special importance. Archaeologists have found mushroom-shaped altars dating back to 3300 BC, and a gold signet ring was unearthed on Crete (dating back to 1500 BC) that shows a young male god floating in mid-air, greeting the Great Goddess. Inside her sanctuary, a mushroom stands as

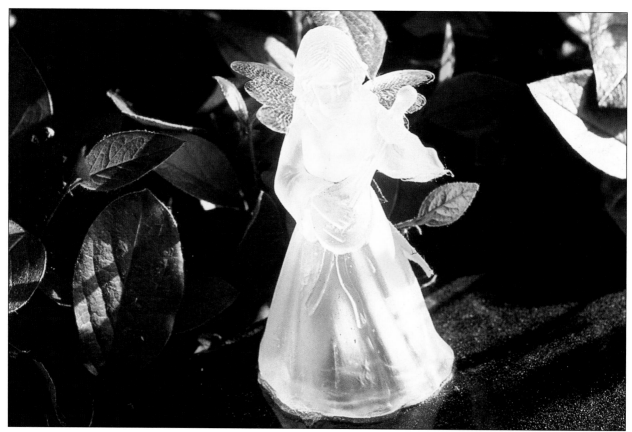

A tiny glass figurine has been placed on the gravestone for Randolph Demuynck (1963–1981) in the Holy Trinity Ukrainian Catholic cemetery near Leduc, AB. Winged messengers who communicate between gods and humans are common to many religions. The Egyptians and Assyrians had winged deities, which inspired the winged gods of Greece and Rome.

the central object. Also, because they grow in the shade of evergreens, mushrooms have been associated with eternal life and the Tree of Life. Interestingly, the grave marker at the St. Albans cemetery, at the rear of the graveyard against a row of evergreens, reveals that Ivan Werbitski lived for 106 years, and his wife Anna for ninety.

One oft-repeated motif—as ornament, or as an actual grave marker shape—is the heart, an ancient symbol of life. In the Egyptian Hall of Judgement, the deceased's heart was placed in the scales and weighed against an ostrich feather. It is also one of the Buddha's eight precious organs. In church cemeteries, the sacred heart of Christ has long been a symbol of sacrifice and devotion. But, in community cemeteries, a heart simply expresses abiding love for the deceased.

A most intriguing custom that has continued into modern times is the use of grave offerings. Just as

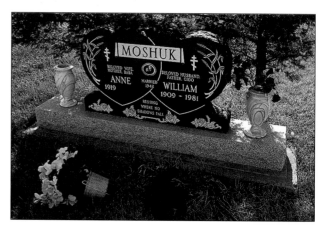

Although the grain motif used on this marker in a Ukrainian Catholic cemetery near Two Hills, AB, obviously refers to a life spent farming, grain has been offered to the departed since humankind began tilling the soil. Sheaves of wheat also symbolize the Divine Harvest, Christ's body, and His rebirth. It was once the symbol for the Greek goddess Demeter. The Egyptians associated wheat with the resurrection of the slain god Osiris.

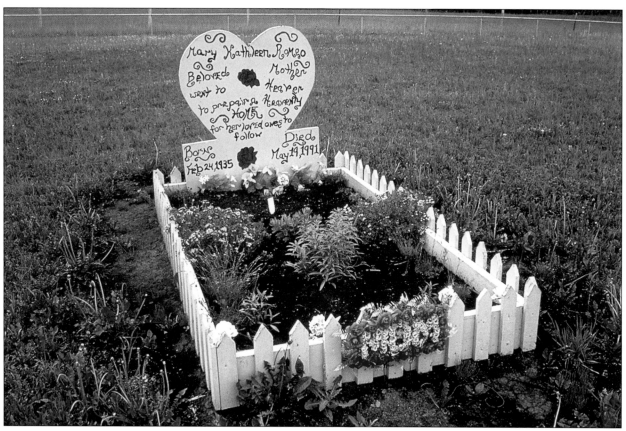

A hand-lettered plywood heart for Mary Kathleen Romeo (1935–1991) in the Green Court, AB, cemetery. This photo was taken only two months after Mary's death. The fenced plot is newly planted.

warriors used to be buried with their weapons or minstrels with their harps, you can still find items left at gravesites that in some way express the lives of the people buried there. Although Danny Sherk (1961–1990), buried in the Valleyview, AB, cemetery, has a modern granite marker over his grave, someone has placed a set of deer antlers at the head of the mound. Danny was obviously a hunter. Other examples abound. In the Vermilion, AB, cemetery, someone has left a football helmet at the gravesite for Colin T. Wilson (1964–1983). In the Central Grove cemetery, near Peace River, AB, two peaked caps hang on the grave marker for Ralph Johnson (1955–1985). A couple of nearby grave markers have similar caps, with crests showing that the deceased men worked for local drilling companies. In the Lakedell Community cemetery, west of Wetaskiwin, Thomas Walker Dorchester (1911–1991) has a miniature

The photograph and the deer antlers on Danny Sherk's grave (1961–1990) in the Valleyview cemetery in northern Alberta suggest that Danny was a hunter. Animal horns have served as religious objects since prehistory.

A miniature cowboy boot and four horseshoes mark the achievements of Thomas Walker Dorchester (1911–1991) in the Lakedell Community cemetery, west of Wetaskiwin, AB.

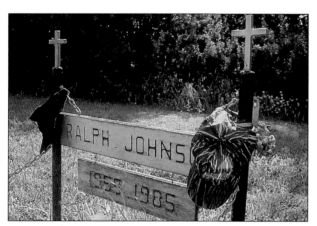

In the Central Grove cemetery, near Peace River, AB, two peaked caps hang on the grave marker for Ralph Johnson (1955–1985).

cowboy boot at the head of his grave. Although the four horseshoes imbedded in his slab honour his achievement as the World Chuckwagon champion (1967, 69,70,71), horseshoes have been symbols of protection since the Middle Ages, and the shape was used by Christians to mark stopping places along the routes of pilgrimages.

But the most common offerings are flowers or wreaths. Not surprising, considering archaeologists have discovered that this ancient tradition has been practised since the Stone Age. Pollen analysis of a fifty-thousand-year-old burial site at Shanidar, Iraq, has shown that bodies were sometimes covered with flowers.

As well as flowers, bushes or trees are often planted at a gravesite. For many civilizations throughout history, trees that remain green year-round have symbolized eternal life. Trees have also been exalted as a symbol of

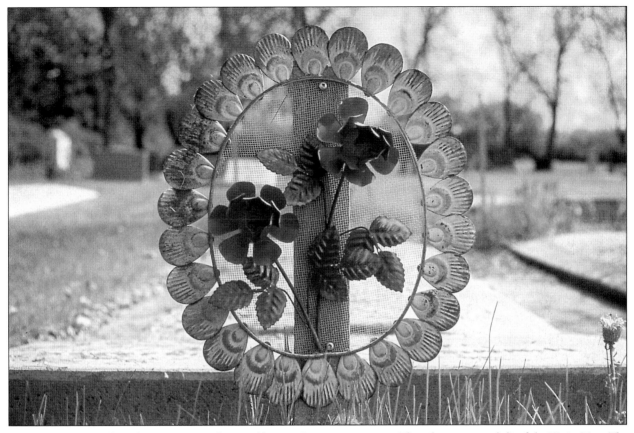

A decorative tin wreath marks a gravesite in the Donalda, AB, Community cemetery. The red roses are symbolic of the Virgin Mary. The border resembles a ring of shells. The spiral markings are an ancient symbol of the womb. Shells were an attribute of Aphrodite/Venus, born of the sea.

the universe and a source of fertility and of knowledge. The oak tree was believed to be the abode of thunder and rain, and many early communities throughout Europe worshipped it. The pine cone is common in Roman funerary art, and symbolizes immortality. The yew tree is a feature of English churchyards, having been revered since Celtic times. The ancient Greeks believed certain groves were sacred, and made offerings to specific trees, hoping to hear prophesies in the rustling of the leaves. Yggdrasil, the sacred ash tree of Scandinavian myth, was thought to support the universe. The fruit from the Tree of Life in the Garden of Eden bestowed immortality. And, as a Christian symbol, the tree and the cross are intrinsically connected. Patterns of vine scrolls, most commonly representative of grape vines, can be found on grave markers in hundreds of prairie cemeteries. Grapes were considered sacred by

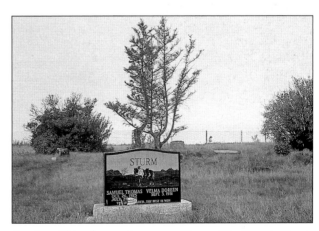

In the Chinook cemetery near Oyen, AB, Samuel Strum's (1925–1991) grave marker has been placed up against a small pine tree, echoing the picture of the tree on the stone. The cowboy and horse are posed at rest.

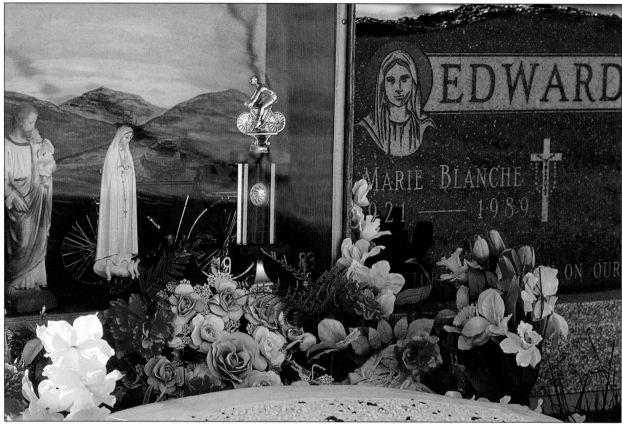

A glass-faced container for Marie Blanche Edward (1921–1989) in the Bracken Community cemetery, in southern Saskatchewan, says much about her life.

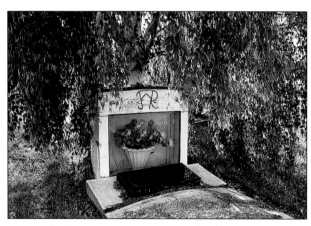

A glass-faced wooden box at the head of John William Reber's (1946–1972) gravesite, in the Valleyview, AB, cemetery. The "JR" brand on the box suggests that John was a rancher. The weeping willow, symbolizing nature's lament, hangs above the grave. The tree is about the right age to have been planted in the year that John died.

the Egyptian god Osiris and the Greek god Dionysus in their roles as agricultural deities, and patterns of grape vines have become symbolic of Eucharist wine, hence the blood of Christ.

Another common custom is the use of glass-faced containers to hold grave offerings. They can be found in church or community cemeteries. Some contain flowers or wreaths; others house small plaster statues of Christ, Mary, or a lamb. My favourites are those that tell us something about the lives of the deceased. Like the one for Marie Blanche Edward (1921–1989), in the Bracken Community cemetery in southern Saskatchewan. Her shrine includes a bicycling trophy, a miniature bicycle, and two small plaster statues. A unique variation on the use of glass-faced shrines can be found in the Lac Ste. Anne cemetery in Alberta, where a hollow fibreglass slab over the grave for Bartholomew Cardinal (1892–1976) displays

This hollow fibreglass slab over the grave for Bartholomew Cardinal (1892–1976) contains three separate glass receptacles, each containing cloth flowers.

three separate glass containers.

Of course, the most logical explanation for using containers is to protect the devotional offerings from the weather. But, according to Herodotus (c. 485–425 BC), a Greek historian, we know that Ethiopians from the fifth century BC used upright coffins made of crystal. After covering the entire body with gypsum and adorning it with paint (until it looked every bit like a living person), they placed the body in a hollowed-out crystal pillar where the encased corpse was entirely visible. The next of kin kept the pillar at home for a full year before carrying it to a site near town. One can only imagine what that cemetery must have looked like. Does this have any relation to the present-day practice of using glass-faced containers? Who knows?

Sometimes my imagination stretches things a bit too far. At one point, I began noticing that, in many cemeteries, people placed small stones on the gravesite. Often the stones were set on the cement slabs, or simply placed beneath the markers. For a long time, I thought the placing of small stones was some fascinating burial custom. Then, one day, I was watching a man ride round and round a cemetery on his mower. He stopped, got off the machine, picked up a small stone that lay in his path, and placed it carefully on a slab. That explained what I had foolishly imagined to be a carry-over from an ancient custom.

But it was an honest mistake: the use of stones and upright boulders to commemorate heroic events, individual lives, or to serve in various religious rites is a very old tradition. Ancient Semitic peoples used to wander into the wilderness for ritual feasts requiring the construction of improvised altars of unhewn stone. There they sacrificed to their gods. For many early peoples, certain rocks and stones in their original,

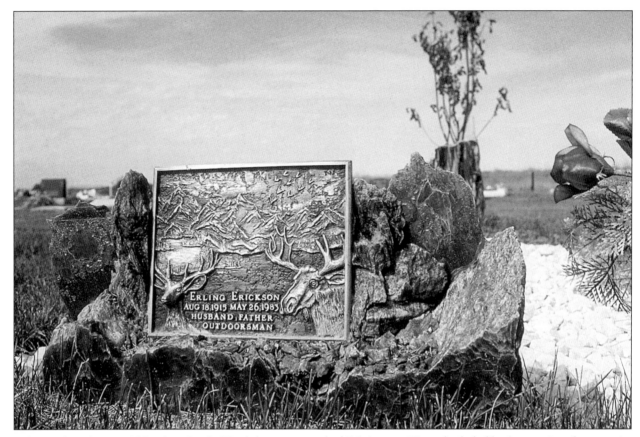

Erling Erickson (1915–1983) is buried in the Waterhole cemetery, south of Fairview, AB. His marker looks like the very piece of a mountain.

natural state were thought to be the abode of some god, and therefore holy. The mother-goddess of Asia Minor, Cybele, was worshipped in the form of a meteoric stone brought to Rome in 204 BC, where a temple was built for it on the Palatine—one of the Seven Hills of Rome.

It was a custom in Scandinavian countries to raise stones in memory of the dead, preferably by the roadside or near a ford. Saxon kings were once crowned on sacred stones, and the English still have their Coronation Stone. To this day, devout Islamic pilgrims travel to Mecca to worship at the Ka'aba, where, according to Islamic belief, resides the Black Stone given to Abraham by Gabriel. In Christian terms, a rock is a symbol for the Church and steadfast faith. It is also a metaphor for the apostle Peter. Water struck from the rock by Moses is an allegory for the spiritual refreshment that the Church provides.

On the prairies, boulders often crown a pile of rocks; as if, finally finished clearing the land, a farmer commemorates the event with a symbol displaying the immensity of the task. But there might be a deeper meaning. In a far valley of the Pyrenees, between France and Spain, as late as 1877, there was a cult of rocks. Upright boulders were placed so that people of the valley could touch the sacred stones and thereby obtain fertility for their fields or for themselves. Sacred stones once existed in various parts of China and were invoked to produce rain and, by women, in the hope of conceiving male children.

Boulders are also used as individual grave markers. In the Lakedell Community cemetery near Wetaskiwin, AB, there is a small painted boulder at the head of the grave for Kathleen (1916–1979) and Erwin Muller (1910–1978). The memorial exhibits a heartfelt attention to detail, evidenced by the carefully painted rose and tiger lily and the hand-lettered names and epitaph—*Life's Work Well Done*. In the Glenleslie

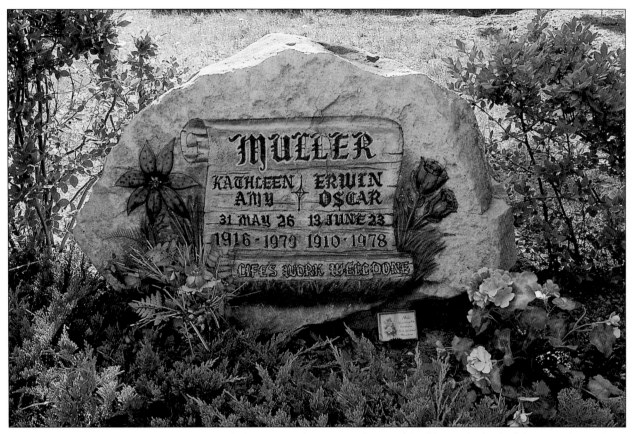

In the Lakedell Community cemetery near Wetaskiwin, AB, there's a small painted boulder at the head of the grave for Kathleen (1916–1979) and Erwin Muller (1910–1978).

cemetery, near Grande Prairie, AB, Lee Bryne Sloan (1943–1985) has a simple fieldstone for a marker. Leaning against the stone is a metal name-plaque and a miniature, silver-plated horse. In the Waterhole cemetery, a little south of Fairview, AB, Erling Erickson (1915–1983) is buried beneath what looks like the very piece of a mountain. Attached to it is a large brass plaque with the profile of a moose and a deer standing before a mountain lake. The epitaph reads: *Husband, Father, Outdoorsman.*

In the Spring Coulee cemetery, between Magrath and Cardston, AB, there is a large rough-cut boulder at the gravesite for David P. Hofer (1915–1985). Attached to the boulder is a figurative brass plaque depicting a man and two horses ploughing a field. The scene obviously represents the labours of a homesteader. But the symbol of the plough has more ancient roots. In Christian art, ploughing is one of the Labours of the Months. In Mesopotamian art, dating as far back

as the fourth millennium BC, a plough was used to represent the Sumerian god of agriculture. Various other cultures throughout the ages, including the Greeks, Hindus, and Chinese, have used the symbol of the plough to ensure a good harvest. Thus, rocks and ploughs are both symbols of fertility. The most practical explanation for this connection might be that once a field is cleared, it's certainly more fertile.

Rocks are often placed all around a grave, like the border around a flower garden. In some instances, the rocks are actually placed in a mound. Sometimes, a mound of rocks is all that remains to indicate a gravesite. It may be that the people who use boulders or rocks to mark the graves of their loved ones have some inkling of ancient traditions, but the practice may have a less complicated explanation, based on economics—a boulder is cheaper than a headstone, and many people, especially during the Depression, couldn't afford even a modestly priced monument.

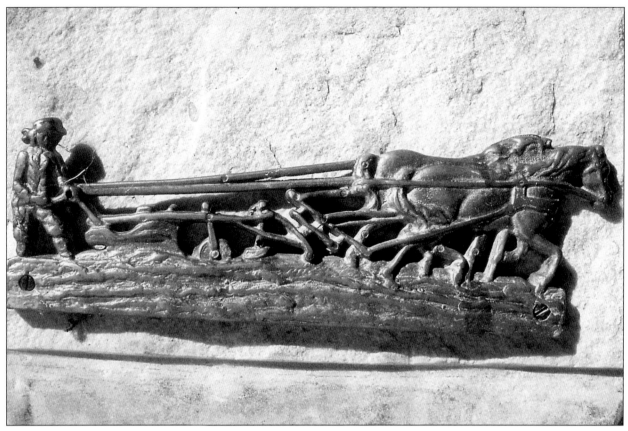

This brass plaque, on a boulder in the Spring Coulee cemetery, AB, honours David Hofer (1915–1985), who laboured as a homesteader.

Even so, that explanation doesn't explain the Mullers' painted rock, or the immense, craggy stone presiding over Erling Erickson's gravesite. As well, in the Reid Hill cemetery—a few miles east of Vulcan, on Alberta Highway 534—the granite markers from an entire cemetery have been moved and placed onto an oval-shaped cement pad. A huge boulder is set at the rear of the pad; the words on an attached brass plaque honour the people who pioneered the area. The boulder has an absolute presence in that vast landscape of prairie fields, indicating to passersby that the uncommon cemetery has a weighty significance.

Peter von Tiesenhausen is an artist who lives on land that he bought from his father, near the northern Alberta community of Demmitt. Peter has been making sculptures from natural materials for years. He has travelled to several different countries, lecturing and constructing his sculptures in galleries, or at

certain sites out-of-doors. When his father died, in 1983, Peter wanted to create a special monument.

"He was my first real close death," says Peter. "This man who had given me unconditional love. Suddenly gone. And I wanted to create something that would help my sons be aware of history. Of aging. Of life and death."

Peter had seen pictures of dolmens, monuments consisting of upright stones, with immense slab-roofs. Such monuments were part of a widespread megalithic culture found throughout Europe.

"So I remembered this granite boulder that was lying out in a field," explains Peter. "It was about seven feet square and two feet thick. Well, I borrowed my brother's cat and skidded it to this little meadow where the blueberries grow; where the family has campfires and roasts wieners. With the help of some friends, I made a Styrofoam plaque and sand-cast it in bronze. Then I chiselled a spot on the boulder for the

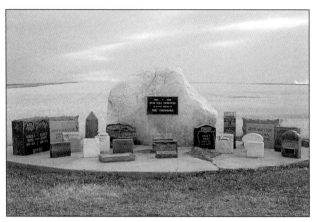

Granite markers in the Reid Hill cemetery honour the people who pioneered the area near Vulcan, AB.

plaque to lie flat. About five years later, I skidded over three other boulders. Soon after that I rented an oil-field truck to lift the big boulder up so that it rested on top of the other three. Like a dolmen."

He remembers the day when he finally decided in his heart that he would spend the rest of his life on the same land. Up until then, his father's ashes had resided in the plastic urn they came in from the funeral home.

"The urn was stored in a small wooden box my father had made. So I called my mother and my brother and asked if they minded whether I spread the ashes."

Peter spent all that day walking quickly about the quarter section, spreading his father's ashes on the land. He also spread them liberally over the dolmen.

"I remember one day having a wiener roast with some friends. The kids were climbing on the dolmen, when, out of the blue, one of the little girls asked what all the white stuff was. I looked up from the fire and said, 'Well, that'd be my father.'"

Although the dolmen for Peter von Tiesenhausen's father is a perfect example of using natural prairie materials to purposefully express ancient burial customs, the original dolmens actually formed the central single chamber of what were once burial mounds. But, over the centuries, the earth mounds disappeared, leaving only the stark architecture of the huge rocks. So, what Peter was responding to was an ancient shape that had already been altered by nature. And, altered again, through the hands of a prairie interpreter—just like whoever made the pyramid for Ethel Skinner, or the obelisk for Ivan and Anna. And the thread of memory stretches just a little bit farther.

An old wood barn situated down a dead end road near Smoky Lake, AB. The white cross emblazoned on the face of the barn testifies to the religious faith of the area's early settlers.

WANDERING UNDER THE DOME OF HEAVEN

✦ *The land lying east from Edmonton, along either side of the North Saskatchewan River, is shaped by gentle rolling hills, with cultivated fields and sheltered pastures. It was there that I began my photographic study of prairie cemeteries. More often than not, I was accompanied by Garth Rankin—an artist and photographer with an eclectic knowledge of history and archetypal symbolism. We'd often start a day trip driving along Highway 45, a stretch of road that follows a CPR rail line through towns such as Andrew, Willingdon, Two Hills, and Myrnam. By mid-morning, we'd choose some side road and then spend the rest of the day aimlessly wandering the rural grid of township and range roads. We found dozens of deserted homesteads—some original log houses being used as granaries or storage, and some places simply abandoned. There were many large wooden houses built in the thirties and forties, the farmyards heaped with broken machinery and automobiles. From the outside, the deserted houses appeared wholly rundown, with sad grey walls and broken, gaping windows. Sagging porches were often strewn with old washing machines or chairs or cupboards.*

Sometimes there was no porch, and grass and weeds grew wild right up to the house. Doors often hung open or ajar.

Curiosity soon got the better of us, and we began snooping through the windows. It wasn't long before we were brave enough to venture through the doorways. What we found still haunts me. Entering the forsaken homes was like walking into another world, one of wreckage and bittersweet artifacts: a single coat hanging

A deserted wood house near Wostock, AB. Home now for rodents and birds.

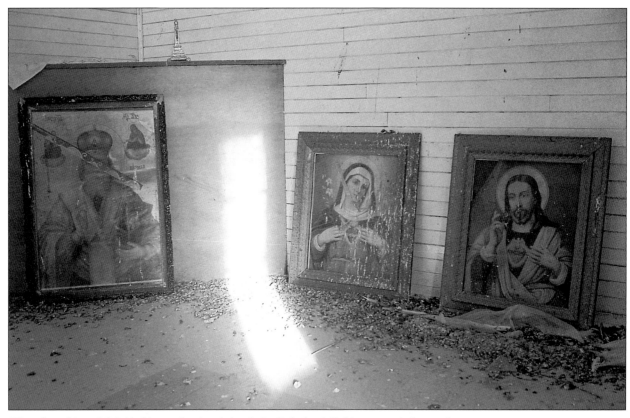

Three framed icons left behind in an abandoned church. In Orthodox belief, icons are windows to heaven.

in tatters over the edge of a door, ties and belts still suspended from hooks on a wall, a set of false teeth resting in a glass on the ledge above a window. Pigeon droppings were splattered everywhere down the walls, and swallows nested in the corners. Ironically, in some cultures, having a swallow build a nest in the eaves of a house is meant to bring joy, happiness, and children. But, in these sad, relic homes, birds and a few rodents were the only occupants.

Sometimes the interiors were strangely beautiful, even in decay, with brightly coloured rooms—yellow or orange—transformed pastel in the diffused window light. We'd often find memorabilia: a solitary cardboard icon or a flower cut from a tin can, an old wooden chest full of mouldy keepsakes, a faded calendar compliments of a garage in some nearby town, with notes scrawled over the dates: *such and such a cow was sick; another cow had just calved; there were nails to buy in town; or a funeral to go to.* There were other things:

children's toys, old magazines and catalogues, scrapbooks, half-completed loan applications. In some places it felt as if the residents had one day simply decided to leave, never to return. Memories hung like spirits in the stale air—clinging tenaciously to the forsaken objects. We found ourselves oddly attracted to the places, yet disturbed by the evidence of lives somehow abbreviated. Such moments were always unnerving. And always the question: what had happened? How could so many once lovely homes be reduced to shambles?

It didn't take us long to find the cemeteries, presided over by the shining domes of Orthodox and Ukrainian Catholic churches. Sometimes we'd peer through a church window at the icons. Once in a while we'd find a church in complete ruin, with the windows smashed out and the door hanging open. One day I was standing in a deserted church, staring up at the dome, which had been painted with dozens of tiny gold stars.

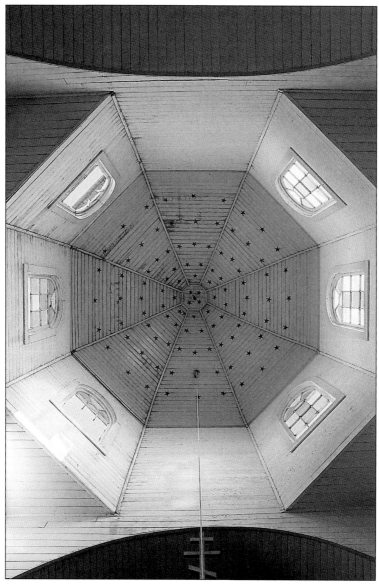

The tiny gold stars painted in the dome of this deserted church symbolize the stars shining in the heavens.

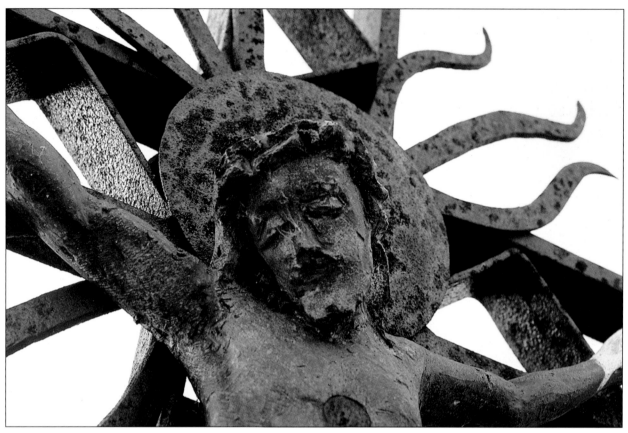

This crucifix, on an iron cross in the Plain Lake Ruthenian Greek Catholic cemetery south of Two Hills, AB, is similar to the description of the statue Emperor Constantine had built when he founded his new capital, Constantinople, in 330.

There were three framed icons propped against the wall, broken and crusted with bird droppings—yet the very air was suffused with their dignity, and the stars seemed to move in the vault of the dome. It was like being under a great cup, an earthly replica of Heaven. And so it was meant to be. For, in the ancient East (birthplace of many Christian symbols), the shape of a cup symbolized the heavens—and perfection and divinity.

The early Eastern Orthodox Church is synonymous with the Byzantine Empire, founded by the Roman Emperor Constantine the Great on 11 May 330. There are many legends that tell of the origins of this vast empire, which lasted for 1123 years. One account records that Constantine originally wanted to build on the site of ancient Troy, but a flight of eagles flew down from the mountains, picked up the builders' tools in their talons, and carried them off to the mouth of the Bosphorus—the strait between European and Asian Turkey, linking the Black Sea and the Sea of Marmara. Byzantium, a one-thousand-year-old Greek city, already occupied the site; but it had suffered greatly during a series of civil wars between various feuding Roman emperors and caesars. Disheartened by the physical and moral decay of Rome, Constantine rebuilt Byzantium and named it Constantinople, proclaiming it the new capital of the Roman Empire. By situating his capital in the heart of the most Christianized region of the Empire, he assured the Christian basis of the Roman state.

But the Emperor was also a superstitious man and liked to hedge his bets—thus he sought blessings for his new capital from all possible sources. He spared no expense, endowing Constantinople with treasures from everywhere within the Empire, both temple statues of ancient gods and Christian relics. From Heliopolis, the City of the Sun in Egypt, came a

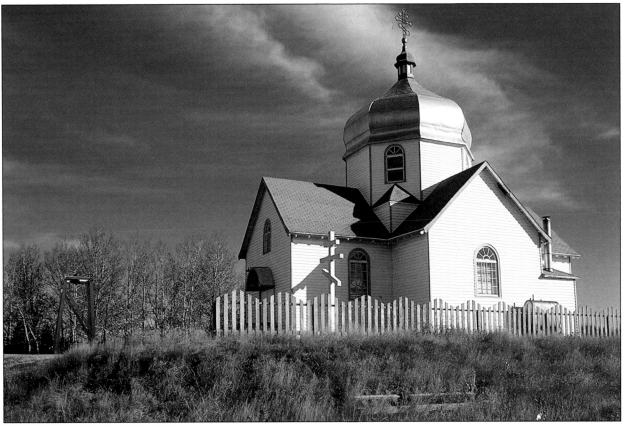

An Orthodox church in Whitkow, SK. Domes, as a distinctive element of church architecture, originated with the magnificent Hagia Sophia (Church of the Divine Wisdom) built by the Emperor Justinian between 532 and 537.

thirty-one-metre (100-ft.) column made from porphyry, a reddish purple crystalline rock. Constantine had the column erected on a six-metre (20-ft.) marble plinth in which were placed objects purported to be Noah's hatchet, baskets used by Christ to feed the multitudes, and Mary Magdalen's jar of ointment. A statue of Apollo—minus the head, which was replaced by Constantine's likeness—was set at the summit of the column. A metal halo, with beams radiating out from it, surrounded the head. Some scholars believe that this statue was the prototype for the modern crucifix.

Constantine built his first church in Constantinople on a site formerly occupied by a shrine to the Greek goddess Aphrodite, and so began the history of domed churches as conspicuous structures. But it wasn't Constantine's church that came to define the architecture of Christendom's domed churches. That honour falls to the magnificent Hagia Sophia (Church

of the Divine Wisdom) built in Constantinople by the Emperor Justinian between 532 and 537. An extraordinary dome, rising forty-nine metres (160 ft.) above the pavement and measuring thirty-three metres (107 ft.) across, crowned the structure. One historian from the time wrote that the interior of the great church was so full of light and sunshine that it had an inner radiance of its own. The interior was decorated with a fifteen-metre (50-ft.) panel, or iconostasis, built of solid silver. An icon of the Holy Virgin occupied the centre.

The Hagia Sophia remained the focal point of the Eastern Church until the Turkish Sultan Mehmet II finally sacked Constantinople in May of 1453. A few days before the Sultan's troops stormed the city, the people of Constantinople awoke to a morning shrouded in thick fog. A strange red glow was visible at the base of the fabled church. It rose slowly to the

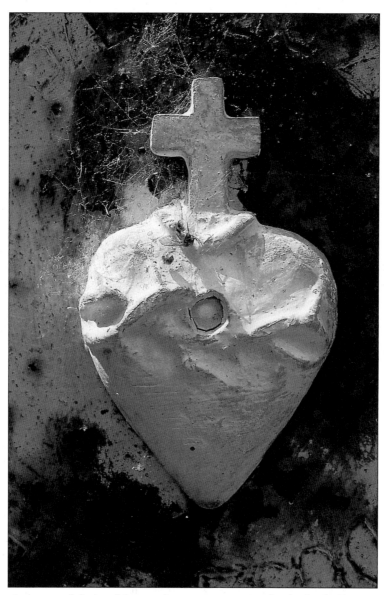

A close-up of the metal heart and cross on a grave marker in the St. Demetro Roman Catholic cemetery near Hilliard, AB.

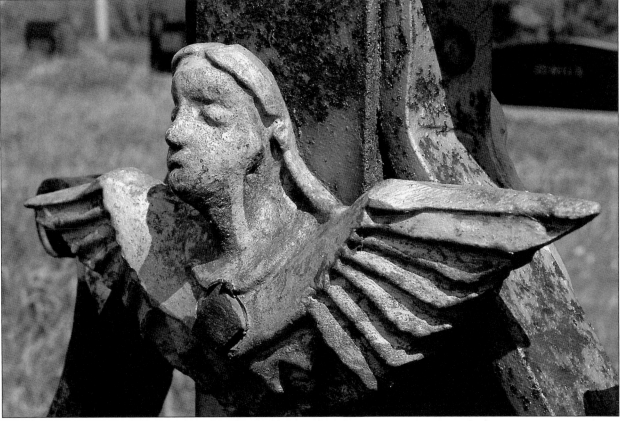

A winged head on a grave marker in the Plain Lake Ruthenian Greek Catholic cemetery south of Two Hills, AB. Winged heads pre-date Christianity by thousands of years. The Egyptians and Assyrians used this symbol in their worship of the sun.

summit of the dome, then suddenly disappeared. The Byzantines believed that the Spirit of God had left their city. A few days later the Turks plundered Constantinople. But the use of domes had already spread to every corner of Christendom, finally to appear four centuries later on the Canadian prairies.

One particular event in the history of the Eastern Church eventually determined much of the religious landscape of the Canadian West. It happened in a place called Cherson in the Crimea, the farthest Byzantine outpost on the northern coast of the Black Sea. There, in the year 988, Vladimir, Prince of Kiev, married Princess Anne, the sister of the Byzantine Emperor Basil II. Although Vladimir's grandmother had been baptized years earlier, it was the marriage and baptism of the prince that brought Russia into the Christian fold. Vladimir divested himself of four previous wives and eight hundred concubines, and the local clergy

began converting whole towns and villages *en masse*. It was from the western principalities of Vladimir's once vast kingdom, Galacia and Bukovina, that the largest portion of Ukrainian immigrants found their way to Canada.

The land east of Edmonton was one of the first areas settled by Ukrainian immigrants. And, like so many homesteaders, one of their earliest tasks was to allocate some place to bury their dead. Because they often settled in groups, each community usually had a stonemason or a blacksmith who was able to fashion grave markers. Thus their traditions continued unbroken. And what wonderful cemeteries—full of hearts and angels and ornate iron crosses, images of the sun and the moon and the stars. The first thing you notice is the colour. Whereas most prairie cemeteries have predominately granite and marble markers, albeit in several different shades, the cement crosses in the

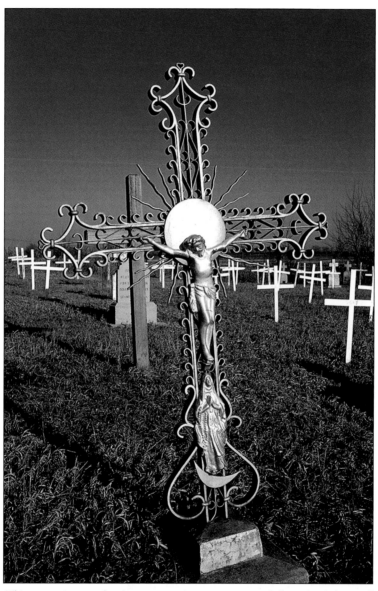

This ornate iron marker in a community cemetery on a hill south of the small Alberta community of Musidora exemplifies the various motifs Ukrainians used on their grave markers. In the background are many small white wooden crosses marking the graves of those whose records may have been lost.

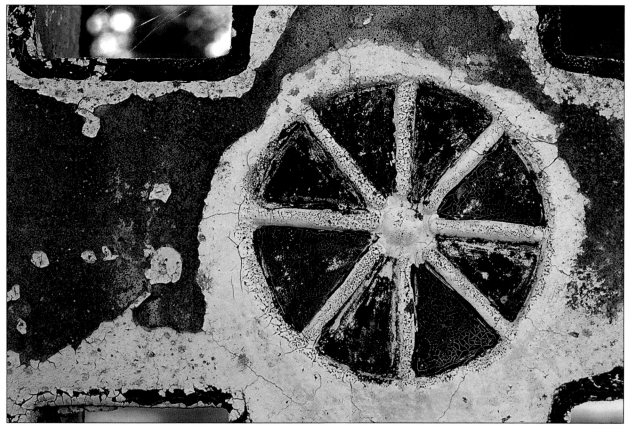

A cement cross painted with wheel-like designs repeats a pattern known throughout ancient Greece, Celtic Europe, and the Far East as a symbol of the sun.

cemeteries of the Orthodox and Ukrainian Catholic churches are often brightly painted—echoing the colours of their religious icons. (The colours are also reminiscent of the interiors of the deserted houses.) Many of the older cement crosses are whitewashed and decorated with symbols, or hung with cloth or plastic flowers.

The trefoil shape, forming the ends of so many of the cement crosses, represents the Christian Trinity—a symbol shared with other faiths. St. Patrick, on an evangelizing mission to the Irish, supposedly used a three-leaf clover as an example of the Trinity. The shape is also a feature on many Gothic church windows. Some of the cement crosses are painted with circular designs or wheels, repeating a pattern known throughout ancient Greece, Celtic Europe, and the Far East as a symbol of the sun. The wheels that "sparkled like topaz" in the vision of Ezekiel may well have been

inspired by a Babylonian solar image. Some of the crosses are painted with designs in the shape of a six-pointed flower, a symbol of the Virgin Mary.

Not only are some crosses gaily painted, but many of the grave slabs are decorated. Often, crushed glass covers the entire surface, bordered with glass of a different colour. Occasionally, a cross pattern is inlaid near the centre. The overall pattern varies, and each slab displays a certain originality. One unique example has the grave plot entirely covered with crushed red garden rock; crushed white rock is used to form a cross near the top, and to spell the word LOVE at the bottom. Many of the crosses display miniature framed portraits of the deceased. It's easy enough, while walking from grave to grave, to imagine the dead are watching every movement.

One of the most poignant markers I've ever come across is in the cemetery of a small Ukrainian Greek

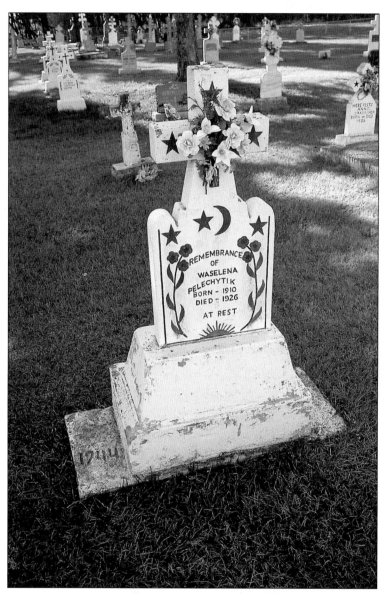

This wonderful cement marker with a Greek cross is unique in that the star motif is repeated on the base of the marker. The three flower heads and the three stars symbolize the Trinity. Whoever constructed the marker must have felt a special fondness for sixteen-year-old Waselena Pelechytik.

Crushed glass decorates the surface of this grave slab in a cemetery near Two Hills, AB.

Waselena Buzak (1879–1957) has a cross cut and shaped from a mirror. The mirror, as a symbol, held specific meaning for some ancient cultures.

Orthodox church north of Hairy Hill, AB. There, Waselena Buzak (1879–1957) has a cross cut and shaped from a mirror. But Waselena's cross is not simply a creative use of a mirror. There is a deeper meaning. In Christian art, a flawless mirror is an attribute of the Virgin Mary of the Immaculate Conception. In Renaissance allegory, a mirror represents Prudence and Truth. And in the ancient Far East a mirror was thought to have magical properties—it warded off evil in this world and the next. As a result, mirrors were buried with the dead. Waselena Buzak's mirror cross stands upright at the head of her plot, facing the rising sun. During the day it reflects the sky and the field across the road. At night, I imagine it reflects the stars.

Evidence of the work of human hands is everywhere.

The churches themselves stand as reminders of a time before modern materials and prefabricated structures. Many of them have distinctive bell towers. The Ruthenian Greek Catholic church of Delph, in the far northwestern corner of the County of Lamont, AB, has a fieldstone bell tower that stands at least nine metres (30 ft.) high. There is an archway in the lower portion, and the upper portion contains three arches for the bells. Three small domes top the structure, with iron crosses at their apex. The tower is reminiscent of Roman architecture, in which arches symbolized the sky and the heavens. Garlanded arches, under which a Roman triumphal procession would pass on its way to the temple of Jupiter, were held sacred by Roman citizens. An even more ancient Egyptian creation myth

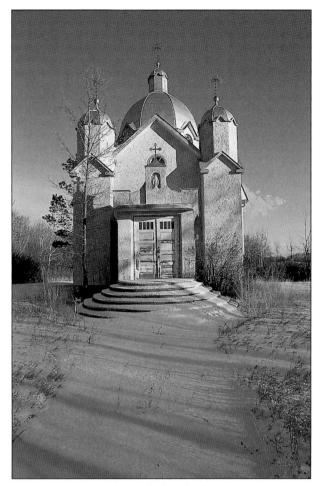

The Ukrainian Catholic church in Hilliard, AB.

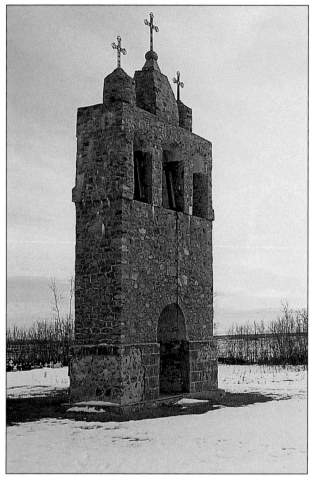

A fieldstone bell tower for the Ruthenian Greek Catholic church of Delph, AB.

tells how the god of the air raised his daughter into the heavens to form an arch over the earth. Christianity borrowed the idea—passing through an arch into the sanctuary at the back of a church symbolizes a transition from death to eternal life. The arch shape is also used for many cemetery entrance gates and grave markers.

Another predominant symbol in Ukrainian graveyards is the crescent moon, a shape important to so many civilizations throughout history that it's virtually impossible to offer any brief description. In the Far East, as in the Mediterranean civilizations, the moon symbolized regeneration and fertility of crops. It eventually came to symbolize resurrection in the afterlife. As well, many female deities were associated with the moon—Minerva, Venus, Diana, Proserpine, Ceres, Isis. The cast has transformed so often over

thousands of years that it's difficult to keep track. So, is it any wonder that many Marian figures—a Christian interpretation of ancient mother-goddess figures—are also represented as hovering above a horned moon?

Most common are small Marian figures attached to iron grave markers, usually placed below a crucifix, and just above a horned moon. Most depict Mary praying, with a rosary tucked in the crook of her right arm. In rare cases the Virgin's likeness can be found placed at the centre of a cross or, more common, is a small figurine of Mary holding the Christ child, sometimes placed in an arched niche near the centre of a cement marker. Some of these markers have glass-faced recesses containing plaster statues of the Virgin. She may be depicted with a crown as the

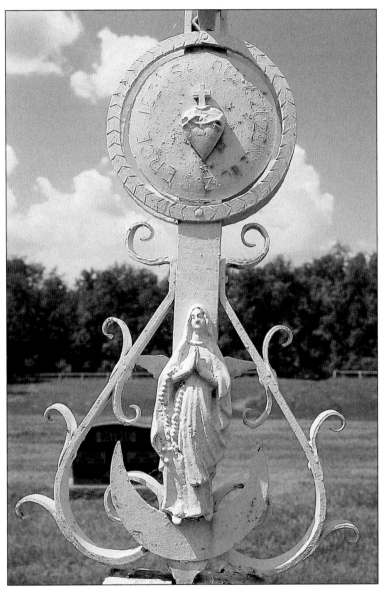

Small Marian figures, like this one in a Polish Catholic cemetery near Hilliard, AB, are common on grave markers in prairie cemeteries.

The cement marker on this gravestone in the Plain Lake Ruthenian Greek Catholic cemetery south of Two Hills, AB, contains a glass-faced recess with a plaster statue of the Virgin Mary.

Queen of Heaven. An interesting representation, though extremely rare, is a small and round cast metal medallion of Mary in peasant costume. And, in the St. John's Ukrainian Catholic cemetery of Borshiw, north of Holden, AB, someone has created a unique shrine. The gravesite is planted with flowering bushes and small trees. Various plaster statues stand amid the foliage. The gravestone is shaped like a heart, with hand-painted lettering and a floral border. Poems are written front and back, one side English, the other Ukrainian. The dedication is to *My Angel Mother, My Goddess, My Queen.*

History is a thread with a long and tattered end, and scholars have been trying to respin it for centuries. One of the joys of photography lies in its simplicity—

once you master the basics, all you have to do is keep your eyes open. And so the sometimes confusing business of research has been balanced by many wonderful hours spent behind the camera. At first, Garth and I simply drove the back roads looking for churches. But, as the miles accumulated, and we found ourselves returning to the same places again and again, we purchased some county maps—Two Hills, Lamont, Minburn, Camrose, Beaver, Smoky Lake, and Thorhild—and used them to better organize our excursions. Because the maps locate church and county properties, we were able to turn our attention to specific areas that contained clusters of cemeteries.

Although the maps eventually became invaluable tools, it took time to become familiar with them. Alberta county maps are large and unwieldy and of little use while driving unless you have them folded just right. Opening them in the car is a last resort. One time Garth and I were looking for a cemetery just south of the small town of Spedden. We stopped by the side of the gravel road and unfolded the map. It extended across the entire front seat of the small Honda—Garth held one side of it while I held the other. We were trying to locate exactly where we were when a farmer pulled up close in his pick-up truck. He rolled down his window and asked if we were lost.

"I think so," Garth smiled. "The map says there's a cemetery. Over there." He pointed to the opposite side of the road.

The farmer looked slowly over his shoulder. "Well, it's not there," he said, and then turned back and leaned through his window to peer down at us over his glasses. "It's there," he nodded over the roof of our car. "You must have got your directions turned around."

I looked out the passenger window and there it was: one small white cross barely visible through some bushes, about three metres (10 ft.) down the embankment, directly beside where we were parked.

"That's quite a fancy map you've got there," said the farmer. And, touching the brim of his cap, he drove off.

Our explorations soon spread south to Hilliard and Chipman, north to Smoky Lake and Vilna. We began

This cement marker, in the St. Mary's Ukrainian Catholic cemetery of Wowedina, near Holden, AB, has a glass-faced shrine containing a plaster statue of the Virgin Mary in prayer. An early spring storm blows across the sky and casts a foreboding light over the cemetery.

following old railway lines that ran through tiny towns like Wostok and St. Michael (south of Highway 45), and Bellis, and Edwand (north of Highway 28). We were soon able to accurately pinpoint where we would find something of interest. The county maps offered clues, as some of the original settlement corners still had names, dots on the map: Kopernick, Ispas, Poky, Stry, Rusylvia, Wowedina, Pruth (a river in Bukovina)—names that can still be found on maps of Ukraine.

There seemed an endless number of deserted churches. All denominations. Had too many faiths vied for too few souls? There's a story of some Ukrainian settlers waiting for their Greek Orthodox priests to follow them from the Old Country. They waited while their children went unbaptized, saying: "Surely while we wait they won't grow horns. And if they do we'll knock them off." But other

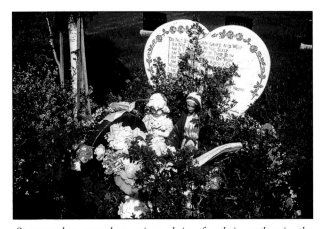

Someone has created a unique shrine for their mother in the St. John's Ukrainian Catholic cemetery of Borshiw, AB.

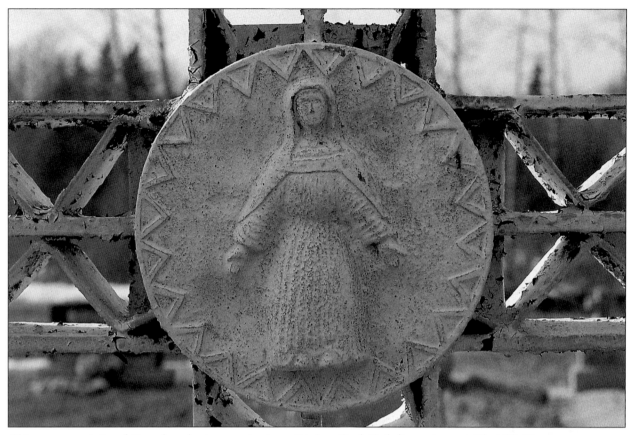

This rare representation of Mary shows her in peasant costume. It is in a Greek Catholic cemetery near Thorhild, AB.

denominations tried to gather these lost souls. One travelling missionary, charged with the task of reporting on conditions in the West, mentioned chickens living in the Ukrainians' homes. He considered it an appalling practice and was once frightened by a chicken when it flapped past him through an open door. He referred to himself as a distinguished guest. It's no wonder the Ukrainians felt they'd do better by knocking the horns off their unbaptized children.

It was a wonderful few years, wandering out at least weekly—photographing through long summer days into the deep shadows of evening, or crisp winter days when the light was so precious it seemed to underscore our hours among the dead. A special discovery marked each excursion: a roadside shrine with a carved wooden Christ, similar to those found in Eastern Europe; a fieldstone tomb at the Polish Catholic cemetery in Mundare, and the magnificent grotto built by the

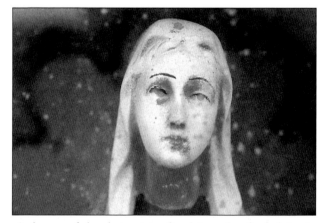

A close-up of the plaster statue found in a glass-faced shrine in the St. Mary's Ukrainian Catholic cemetery of Wowedina, near Holden, AB. Her chipped, moon-white face seems to express perfectly the Virgin Mary's attributes of Love and Chastity.

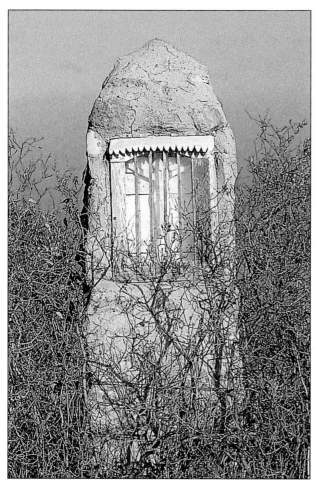

A rare wayside memorial shrine containing a carved wooden Christ, south of Holden, AB. Such roadside shrines are common in many European countries.

Basilican Fathers at the northern edge of town; a coloured mosaic frame inlaid around a faded portrait, small and simple, and yet so very expressive of someone's affection for the deceased; a small wooden cross for Johanna Scheck (1928–1982) in the Ukrainian Catholic cemetery at Skaro, decorated with red-painted flowers; the gardenlike landscape of the cemetery at Dickie Bush.

Moments of wonderment and often complete serenity accompanied each new discovery. One frozen winter evening we found ourselves standing under a tall crucifix in a Polish Catholic cemetery. A plaster statue of the crucified Christ hung bone white over our heads. Behind us, a full moon glimmered in a royal blue sky. Of course, there were other, less serene moments: the inevitable flat tires, discovering the

camera battery had died at just the wrong moment, being caught in a blinding snowstorm miles from any pavement, or watching a sudden thunder shower turn the long road ahead to quagmire.

Once when I was photographing the interior of a deserted house, looking through the lens and concentrating on my focus, Garth heard noises from down the driveway near the road.

"Did you hear that?" he whispered. But I was too focused on the few square feet in front of my camera to hear anything.

The next thing I heard was a bullhorn: "You, in the house. Come out. Now!"

What followed was a fiasco. I refused to leave without my camera equipment, and took a couple of minutes to gather it up. Outside, the officers were getting anxious. The one with the bullhorn repeated his command. When I finally walked out the side door into the overgrown and shaded driveway, cradling my tripod in the crook of my arm, I didn't once think that it might look like a rifle. After everything got sorted out—and we were warned about trespassing— it was hard to say who was more embarrassed: Garth and me for trespassing, or the officers for pulling their guns.

For the most part, though, the locals we met were less reactionary and quite willing to spend time chatting with us about their communities. Many an interesting conversation was struck while having lunch in a small-town cafe, snooping about in a second-hand store, or quaffing a couple of beer while watching a hockey game in a country tavern. Our interests branched out for a time, and we focused on seemingly deserted villages such as Musidora and Morecambe, or depopulated towns the likes of Hairy Hill and Chipman. We examined the old false-fronted buildings that lined the wide empty streets, or modern icons like the many relic gas station signs. Garth liked taking close-ups of things, looking for juxtapositions of order and decay. For this he used his large-format camera, a bulky affair that required some assembly and much patience. More than once someone drove up to ask what on earth Garth was doing under that black cloth, focusing his camera at a seemingly innocuous wall.

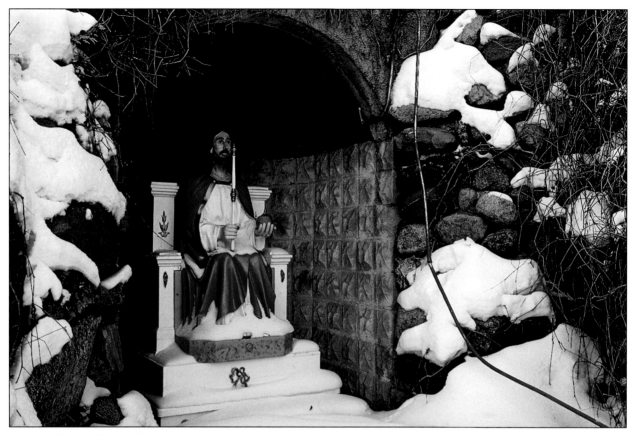

A statue of Christ the King in the magnificent grotto built by the Basilican Fathers at the northern edge of Mundare, AB.

But more often than not we spent entire days in the country, and it was a rare occurrence to meet anyone. Maybe an occasional farmer curious about the goings-on, or wondering whether our car was broken down. One day we were exploring a deserted town on Highway 45. I was focusing on the row of vacant buildings along the highway when a farmer in a pick-up truck stopped to ask what I was doing.

"You after some history?" he asked, standing there in his grease-smeared coveralls, spread legged, arms crossed.

"Yeah, I guess," I answered, looking him square in the eyes. He held the gaze for a long moment.

"Minden, this here was called," he began, running his thumb along the brim of his cap. "That first place was a blacksmith's shop." He pointed to a grey door hung with wind-torn auction posters. "That next place was a restaurant. The last one was the post office. Yeah. It used to be a town about thirty years ago.

There was a school over there by the tracks. We had grain elevators, too. But they've been moved north to Ewasiuk's place. Better he get them than they burn down. Lots do. Some get demolished like they're just so much junk."

We stood talking for a while before he said it was time to be getting back to work. "Though it don't make much difference," he chuckled. "I can go broke just as easy standing still."

After he left, I stood looking at Minden. Barely a dot on the map. Three false-fronted buildings floating on a sea of weeds. I could see through the window of the old blacksmith's shop to a greasy workbench covered with tools and big-toothed gears, over which hung the reflection of fields stretching off to the horizon. I walked around behind the buildings and found a rusted car, a Zephyr, sitting in a vacant lot. I thought about how the Zephyr was related to the god of the

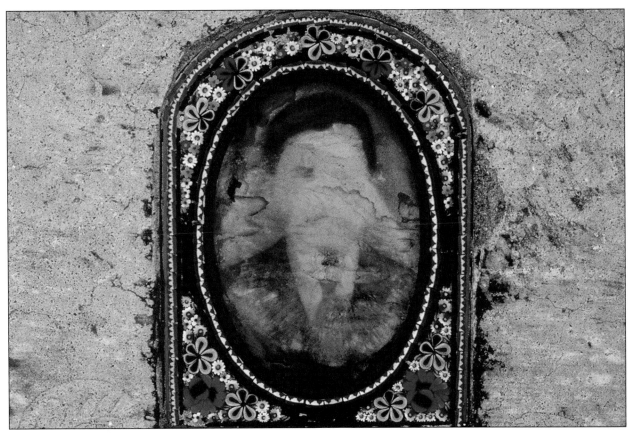

A coloured mosaic frame inlaid around a faded portrait, deeply expressive of someone's affection for the deceased. This unique motif is placed in the face of a granite marker in the Ukrainian Greek Orthodox cemetery near Thorhild, AB.

west wind. About how the West was a dream. I thought about the promises. Prosperity with the railroad. You can build a future here. Raise kids.

But the railroad stopped running, and most of the kids moved to town. Paved roads made it easier to shop in the bigger centres, and technology made it unnecessary to have lots of kids to work the farm. Not to mention unprofitable. As farms got bigger, the smaller towns died. There were just too many of them. Those farmers who remained on the land moved into modern houses and used the old buildings as granaries, or left them to rot. A woman who owns a second-hand shop in Smoky Lake once explained to me how second-generation farmers, finally able to afford modern furniture, simply discarded the primitive handmade artifacts built by their predecessors. "It's the grandchildren who come out now from the city looking for these old things."

It was a very cold and windy Sunday in April when I visited the Greek Orthodox church of Star. I had been invited by the Reverend Father Evan Lowig to witness the Paschal grave blessings, when local Ukrainians gather at their cemetery to share communion with those who have gone before them. Arriving late, I missed the memorial in the church where the names of all parish members, living and dead, are read aloud. By the time I got there, the parishioners were already gathered on the church steps; some were slowly making their way to the cemetery. Although the wind had a fair bite, a bright sun shone in the late morning sky—the sight of it was enough to warm any prairie soul.

I made my way to the grove of trees at the centre of the cemetery and waited for the ceremony to begin. Bowls of fruit and plates of bread had been placed on all the graves. Fresh bouquets of flowers filled the vases. It was pleasantly calm in the trees, where I stood

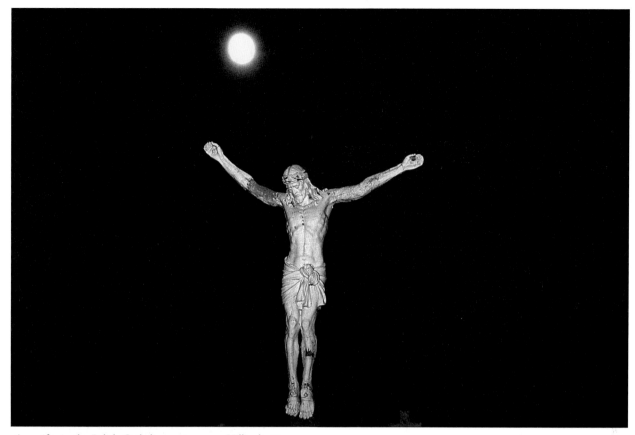

A crucifix in the Polish Catholic cemetery near Hilliard, AB.

watching the procession march around the perimeter of the cemetery. At the head of the line a man was carrying a processional cross—like a soldier carrying a flag—a sign of the victorious Christ, symbolizing the trampling of death. The priest then stood before each grave and said a prayer to help the deceased along to Holy Bliss, all the while waving his censer rhythmically to and fro, sending the sweet smell of incense wafting through the cemetery. It was an ancient ceremony, the essence of which has been practised by Slavonic peoples since pre-Christian times.

I noticed an old woman looking at me, and I was immediately nervous. Did she feel that I was presumptuous in being there? There was a brisk wind, and she stood with her hands thrust deep into the pockets of her long coat. Barely one and a half metres tall (5 ft.), she seemed rooted to the spot. She nodded to the tombstone where she was standing, her wrinkled face staring hard at me from under her hat and hood. But, finally, she broke

A small handmade wooden cross for Johanna Scheck (1928–1982) in the Ukrainian Catholic cemetery at Skaro, AB.

into a wide smile. I pointed to the stone and then at her. She nodded, yes. It was her husband's gravestone, but her name was there, too, "Joanna." Only the date of death was blank. She was smiling because it was her grave, and yet she was still standing squarely above it. A young boy, presumably her grandson, was climbing the metal railing that bordered the plot.

After the ceremony, everyone proceeded to the community hall.

"The feast signifies the abundance of Paradise," explained Reverend Father Lowig, waving a hand towards two long tables set with all manner of Ukrainian food. "Hence, the abundance. In which I surely plan to partake." And then he joined his parishioners at the head table. In Orthodox view, the priesthood exists for no other purpose than to make manifest the Kingdom of God to all—from birth until death. As well as baptisms, weddings, and funerals, Reverend Father Lowig blesses the homes and the fields.

I thought about my fascination with Ukrainian cemeteries. Certainly, curiosity was at the heart of it. And the symbolism, rooted in ancient myths and legends. The cemeteries harboured a profound sense of continuity. Then I remembered Joanna and our moment of serendipity—a moment no camera could capture. There lay the crux of the matter. In that one moment, I had learned more about Ukrainian cemeteries than in all my study of books. Just as the original settlers once proceeded around the cemeteries trampling death, so their descendants followed in their footsteps. Joanna knew exactly where she was going to be buried—under the moon and the stars.

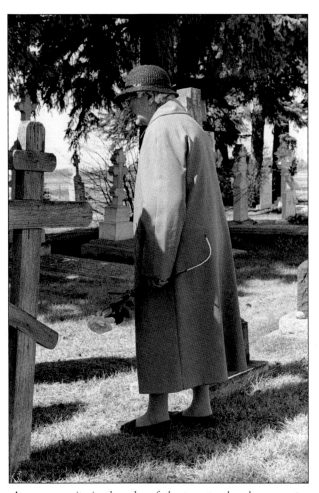

A woman waits in the calm of the trees to place her rose at a gravesite, a custom also practised by the ancient Romans.

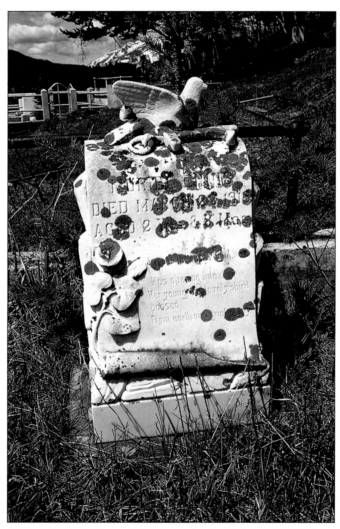

This marker in the Roman Catholic cemetery in Blairmore, AB, depicts a dove and an anchor. The dove is symbolic of the Holy Ghost, and early Christians used the anchor motif to disguise the shape of the cross.

AN UNCOMMON JOURNEY

One of the most common shapes for cemetery markers on the prairies is the cross. Given the importance of the cross to Christian belief, the reason seems obvious enough. But nothing about death and symbolism is as simple as it seems. The cross has been used since the dawn of civilization, as ornament and as a religious symbol. The origins of the cross as an archetypal symbol could be as ancient as the practice of kindling a fire with two sticks, which might explain how the symbol of a cross eventually came to be used by the Assyrians to represent the four directions in which the sun shines. As decoration, the cross shape was used on the bottom of drinking vessels found in graves dating back to Bronze Age Europe. As for crucifixes, which represent Christ on the cross, human effigies have been hung on crosses as scarecrows since ancient times, and human sacrifices were once hung on crosses before they were chopped to bits and spread on the fields to encourage good crops.

In the early days of Christianity, very few followers used the symbol of the cross. It was viewed as a Roman torture device, and the Romans certainly attached no religious significance to it. Considering that only disreputable people died on it, such reluctance to display the symbol is easily understood. But many early Christians maintained that Christ's death had sanctified the torture device, and they adopted the custom of making the sign of the cross on their foreheads. In fact, the practice became so general that by the year 200 Christians made the sign before undertaking any action—eating, drinking, conversing, before and after journeys—and small crosses began to appear in their homes, where church services were originally practised. Christians became known as cross-worshippers, and their pagan neighbours would taunt them with: "you worship that which you deserve." But such an insult could also be a portent, because the punishment of the cross continued in the Roman Empire until at least the first half of the fourth century.

Early Christians often disguised the cross by using various symbols, such as an anchor or the trident. It's not known for certain if the Latin cross we use today is the same shape as the cross used by the Romans. Some scholars insist the Romans used stakes or poles,

This cross, for young Edward Malchow, stands in the Catholic section of Alberta's Stavely cemetery.

This cement marker in the Ruthenian Greek Catholic cemetery at Delph (in the far northwestern corner of the County of Lamont, AB) bears the letters INC. It is a variation of the monogram that Constantine the Great used in 312 (In This Conquer) after experiencing a vision in which Christ appeared and told the emperor to place it on his banner.

and there are references in the Bible to bear them out. Others contend that the cross used for punishment was in the shape of the letter 'T', or Tau cross, which the pagan Druids made by joining two limbs from oak trees. In Acts 5:30, Peter chastises the council and elders of Israel in Jerusalem: "The God of our fathers raised Jesus whom you killed by hanging him on a tree." In the first letter of Peter 2:24, he says: "He himself bore our sins in his body on the tree."

It was Constantine the Great who finally brought the symbol of the cross into respectable usage. Back in 312, when he was campaigning in Italy, he is said to have had a vision in which a luminous cross appeared in the heavens, along with the words "In This Conquer." That same night he had a dream in which Christ appeared, admonishing Constantine to place the symbol on his banner. Constantine did so, and even had the emblem painted on his soldiers' shields.

The opposing armies were routed.

Although this auspicious victory ensured the respectability of the Christian symbol, the cross used by Constantine was not the familiar Latin cross, but rather a monogram formed by the superposition of the two initial Greek letters, chi and rho, of the name *Christos*. Variations of Constantine's monogram regularly appear on grave markers: INC or INS (formed of the first three letters of the Greek word for Jesus), and INRI (which stands for the Latin inscription that Pilate ordered placed on Jesus' cross—Jesus of Nazareth, the King of the Jews).

It wasn't until the fifth century that the undisguised cross first appeared, and, in the centuries that followed, the basic shape assumed many embellishments. The two elementary forms are the Latin cross (with the transverse shaft set about two-thirds up from the bottom) and the Greek cross (with the transverse shaft set at

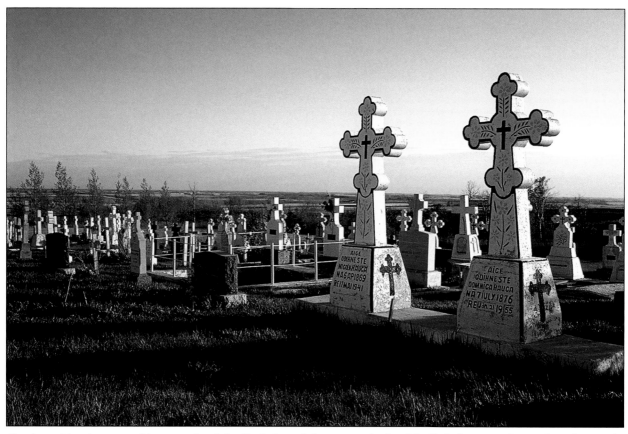

On the prairies, the most striking examples of the Greek form of the cross can be found in Orthodox cemeteries—such as these in the St. Pokrova Ruthenian Orthodox cemetery near Smoky Lake, AB.

the centre of the vertical shaft). On the prairies, the most striking examples of the Greek form can be found in Ukrainian cemeteries. This form has been called the Budded Cross, because the trefoil ends resemble a flower. Although usually placed on a high base, which, from a distance, makes them appear Latin, a closer view reveals their true shape.

And here we might add another category: hybrid prairie crosses. Whether made of iron, cement, glass, plaster, or lead, the crosses in prairie cemeteries are unique variations of very old themes. In addition to the diverse patterns offered by local monument companies, many people have chosen to fashion their own crosses. Maybe they did so from a feeling of deep affection, a need to create a special monument for their loved ones. Perhaps, in many cases, they simply couldn't afford a commercial monument, and so they used their imagination.

A handmade marker for Garnet Wilkinson (1852–1975) in a community cemetery near Glentworth, SK. The unique Latin cross is made from white rock imbedded in cement.

A ceramic flowering cross for Joseph Gourin (1859–1939) in the St. Isadore Roman Catholic cemetery in Plamonden, AB.

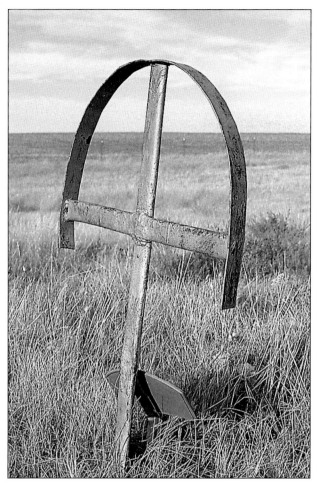

A cross imprinted into the cement marker for John Champagne (1893–1967) in the cemetery at Batoche, SK. The leaf imprints symbolize both the Tree of Life and the wood of the True Cross.

An iron cross in a cemetery near Glentworth, SK. The arched bar over the cross is symbolic of the sun.

One very interesting example can be found in a cemetery just north of Thorhild, AB. Fashioned from two wrought iron beams and raised on a rectangular cement column, it's basically a Latin cross, with the transverse shaft set about one-third the distance from the top. The base upon which the column sits consists of three levels, or steps, symbolizing the steps to Calvary—from bottom to top: faith, hope, and love. The ends of the cross have been sheared to sharp points, which represent the suffering of Christ on the cross. The maker then attached a circle with spiked rays to where the two shafts meet, to symbolize the sun. A crescent moon has been placed lower down on the vertical shaft. Although each adornment is obviously intentional, it's doubtful that the maker

knew he was paying homage to so many ancient traditions. The marker is a true prairie hybrid.

Any study of crosses leads inevitably to crucifixes. Representations of the Crucifixion didn't become general until after the sixth century. Although realistic reproductions of the Crucifixion began to appear in the eighth century, with Christ adhering to the cross, He was shown clad in a long, flowing tunic. The head remained erect and bore a royal crown, representing Christ as triumphant and glorious. In the tenth century, the tunic was shortened, reaching from the waist to the knees. From the eleventh century in the East, and from the Gothic period in the West, artistic treatment of the crucifix tended towards realism. The head was shown drooping onto the breast, and the

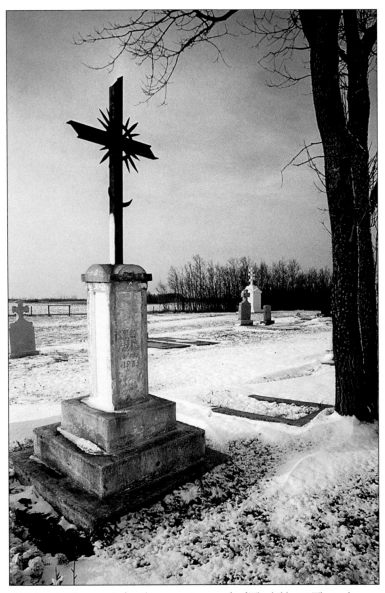

This imaginative cross is found in a cemetery north of Thorhild, AB. The twelve rays represent either the twelve tribes of Israel or the twelve apostles. Interestingly, the Babylonians hung a crescent on a cross to symbolize their moon deity.

In the thirteenth century, complete realism was achieved by the crossing of the legs and the substitution of one nail in the feet, instead of two, as in the old tradition.

crown of thorns appeared on His head. The arms were pulled back, the body was twisted, and the face was displayed wrung with agony. In the thirteenth century, complete realism was achieved by the crossing of the legs, and the substitution of one nail in the feet, instead of two, as in the old tradition. Thus, the living and triumphant Christ gave way to a crucifix accentuating the agony of His death.

My particular interest in crucifixes began one spring day in a Greek Orthodox cemetery about sixteen kilometres (10 mi.) north of Willingdon, AB. I was using my new macro-lens, to take close-up photographs, and was focusing on a crucifix hung at the centre of a cement cross. The entire cross, including the crucifix, had been painted blue. But the colour had faded and some of the paint was peeling. Nature had worn smooth the body of Christ. Although small enough to fit in the palm of my hand, viewing it through the lens

This depiction of Christ on the cross tends towards realism.

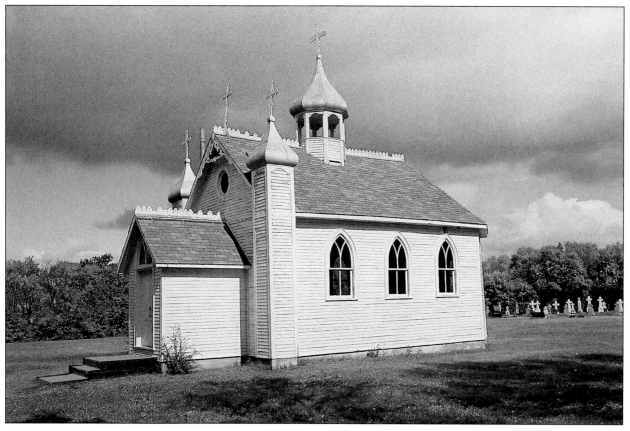

This wooden Orthodox church near Veregin, SK, is a fine example of old country craftsmanship. The domes are shaped in the Russian fashion and were developed in response to weather conditions because the onionlike shape sheds snow easily.

made it seem larger than life. It brought to mind the people buried in the cemetery, shaped by faith and long labour on the land. How often had some poor soul looked up to heaven for strength enough to finish a task? And now the blue Christ was left to face the elements—so small in the landscape, yet so large in the minds of the faithful.

It was about this time that I met Greg Gerrard. A tall man with a nest of thick grey hair and a laugh that could curdle cream, Greg is an inveterate traveller. His employment as a book salesman on the prairies has required him to drive thousands upon thousands of miles. He knows the back routes, the less travelled highways. He is undaunted by distances. We began our friendship by attending farm auctions and visiting rural second-hand stores, looking for original prairie furniture, folk art paintings, or ethnic weavings. Although Greg's home in Didsbury, AB, is already a

mini-museum of oddities—homemade pine chests, jelly cupboards, washstands, benches, hand-carved whirligigs, and wagons—his passion for collecting knows no bounds. My growing obsession with photographing cemeteries, coupled with his appetite for collecting folk art, led to many memorable excursions. Thanks to Greg, my study extended to rural areas I might otherwise have missed. As well, he has a knack for finding the extraordinary.

Greg and I drove the prairie distances, each in our own way searching for the past. Hardly a trip went by when he didn't find some collectable treasure, maybe a hand-woven rug, or a brightly painted bench. His passion for handmade artifacts opened my eyes to the handiwork found on old houses and churches, like the patterns of cutwork around old porches or on church gables. Our trips began to take on a particular routine that included visiting the towns and villages. He was a veteran

The stems of plastic flowers behind the crucifix reveal the scale. So small in the landscape, yet so large in the minds of the faithful.

of motels and restaurants, and simple day trips turned into longer journeys—three or four days, two weeks.

So it was in the fall of 1991 that Greg and I set out on a trip across the prairies in search of folk art and crucifixes. We spent much of the spring and summer planning the journey, marking maps and studying settlement statistics, trying to ascertain which cemeteries might contain the most interesting crucifixes. We chose a route leading along the edge of the poplar belt extending across the Prairie provinces. But, unfortunately, a few weeks prior to departure, I twisted and broke my ankle.

"Look at it this way," said the doctor. "You could have broke it in a worse place."

Well, not as far as I was concerned. I stewed for a few days before finding courage enough to call Greg. What could I say? *Sorry, this trip we've been planning for months can't happen.* But, to my surprise, he called first. I explained my situation, and then there was a long silence.

"Do you still want to go?" Greg finally asked. "I can pick you up in Edmonton. Spend a couple of weeks travelling. Whaduyuthink?"

What followed was a curious whirlwind tour of the prairies—two weeks driving secondary highways and back roads. We started out trying to camp, but my broken ankle proved too much of a burden, so we stayed in motels. Each day we set out with a handful of maps, sometimes visiting more than twenty sites before dusk. Our cameras clicked madly. *Did you shoot the spire? Yeah? Good. How about the churchyard cross? The cutwork around the windows?* It was the kind of journey photographers dream of—a cinemagraphic stream of images so varied that one forgets the order of things. But my broken foot tempered the excitement. Most mornings it was dead weight, and my toes looked like raw sausages.

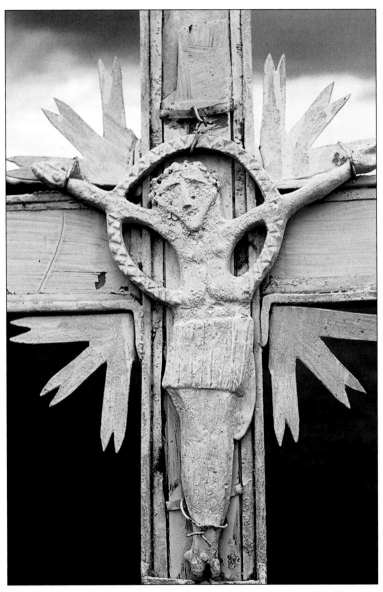

A rare example of a handmade crucifix, hung on the cemetery cross in the Ukrainian Orthodox graveyard in Bellis, AB. The marker is fashioned from wood and iron. The sun's rays are made from tin, and the crucifix is lead.

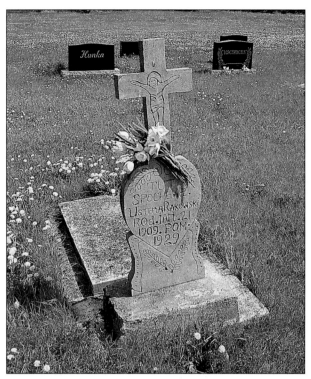

This wonderful cement marker, in a Ukrainian Orthodox cemetery just south of Radway, AB, is a fine example of local craftsmanship. The crudely scrawled crucifix and hand-decorated, heart-shaped base are uniquely expressive of the ingenuity of local craftspeople.

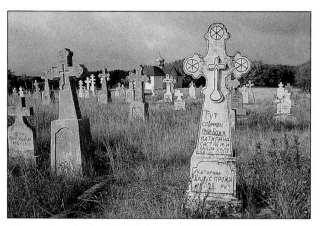

The cemetery for the St. Nicholas parish of Drobot, SK. The cement marker in the foreground has a cross and orb motif, symbolizing the Triumphant Christ. The six-spoked wheel (or six-petalled flower) is symbolic of the Virgin Mary.

Still, whenever I began to feel sorry for myself, we'd come across some remarkable cemetery. On one of our first days, we found the community of Drobot. It lay at the western edge of Good Spirit Lake, just north of Yorkton, SK. The Rural Municipality map led us ten kilometres (6 mi.) down a "bladed but undrained road," one grade up from a "prairie trail"—important designations, because some roads can turn to mush after only a brief rainfall. We found the cemetery on a knoll about ninety metres (293 ft.) south of the church. Using my tripod as a crutch, I plodded amongst the white crosses, swinging my useless leg forward with each step, as the sharp grasses speared my toes through the wool sock. I was busy grumbling about the disability when I caught a glimpse of something lying in the tall grasses at the base of a cross: a yellow rat-tail comb, and a 1984 calendar notebook.

I managed to pick up the notebook, and flipped through the crinkled pages. There was a choir schedule and a list of individual laments from the Bible. The notebook once belonged to a priest. His teeth were giving him trouble that year, there were several dental appointments. And his Volkswagen was in the shop a lot. He had scrawled some directions on the back cover: "go across the railway track a block down from the school, go east & south to #366 highway, gravel for two miles, you hit a dead end, then 5 miles east." I chuckled, remembering the number of times that I got hopelessly lost following just such directions. Tucked inside the book was a small sheet of paper with sermon notes. It opened with Psalm 46: "God is our refuge and strength, a very present help in trouble. Therefore we will not fear though the earth should change." I thought about the words and stood looking around at the field of crosses—mostly untended plots, with hardy bushes growing through the cracks of the concrete slabs. Dark-bottomed clouds rushed overhead like a sea, and yet it was strangely calm in the cemetery. There, for one short moment, I could sense the rotation of the earth, and felt wholly alive and satisfied.

As for crucifixes, there seemed an endless variety—a long and storied legacy revealed in cemetery after cemetery, where traditions and memory have combined with necessity, giving rise to portrayals that are decidedly unique. Some of the most interesting are the hand-painted variety, such as the one in a Saskatchewan cemetery for a settlement called Ukrainia, where the tiny face is shaped like a heart. Another truly curious

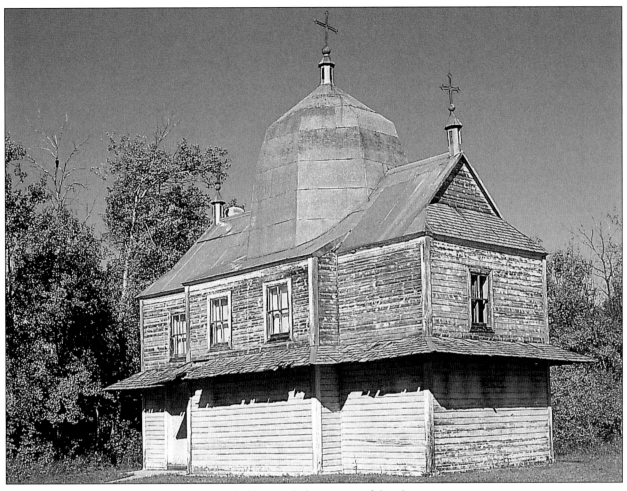

A derelict church near Veregin, SK, looks like two buildings stacked one on top of the other.

rendition, in a nearby cemetery, has Christ looking more like the gingerbread man, and was probably the work of a child. And then there's the carefully painted, life-sized plywood cutout, portraying the crucified Christ. Suspended high on a wooden cross set at the entrance to a cemetery near Norquay, SK—head bent low and wearing a crown of thorns, the arms perfectly trace the horizon.

The weather remained unsettled for the entire two weeks. Some mornings promised sunshine only to cloud over by noon. And the wind blew every day, sometimes so strong the only thing holding me to the ground was the weight of my cast. Nonetheless, we faced each new day with renewed energy and were amply rewarded for our dogged efforts. Quite often it felt like we'd stepped through some portal into the past. One afternoon we

found a small log church hidden in some trees down a dead-end road. There was a log bell tower, too, with poplar saplings growing through the chinks.

The door to the church almost came apart when we opened it. Inside, crumbling paper icons were tacked to the walls and faded cloth flowers framed a small archway. A rotting cloth banner lay on the floor, beside a processional cross, with the date 1906 carved into it. A fine-grained layer of dust covered everything, as if time had stopped. That same day we found another derelict church. This one looked like two buildings stacked one on top of the other. There were no windows on the lower portion, and the dome was constructed of small sheets of tin, forming only a rudimentary shape. Probably, it was all the congregation could afford, and it stood as a reminder of the determination,

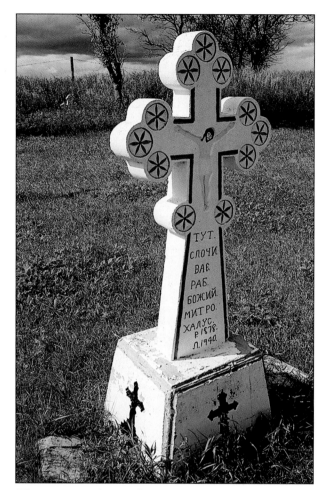

This cement marker, in the Holy Ascension cemetery south of Canora, SK, is a truly unique example of the Budded Cross. The hand-painted trefoils give it a remarkably joyous appearance. The crucifix reflects tenth century portrayals of Christ, with the tunic reaching from the waist to the hips. As a special touch, the artist has painted the face in the shape of a heart.

faith, and ingenuity of prairie settlers.

One afternoon we were photographing in the Green Leaf Ukrainian Orthodox cemetery, east from Endeavour, SK, when the caretaker, Walter Boychuk, stopped by to see what we were doing. At first he was skeptical, and who can blame him: Greg with his head of snow white hair and matching turtleneck sweater, looking every bit like a television evangelist; and I in my coveralls, hobbling beside on crutches. But it didn't take Walter long to realize we were harmless. And, when we asked to see the interior of the church, he kindly drove several miles home to get the keys.

Inside the church were an old barrel-shaped wood

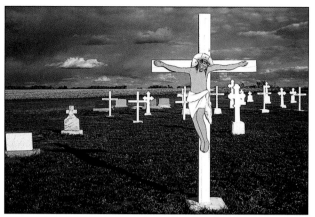

This painted, life-sized plywood cutout, portraying the crucified Christ, is suspended high on a wooden cross at the entrance to a Ukrainian Catholic cemetery near Norquay, SK.

stove and several rows of handmade wooden benches. A processional banner stood against the wall. Walter explained that his mother, Zoya Boychuk, had been largely responsible for contracting the construction of the church. Built in the early 1920s, the wood had been cut from the Porcupine Forest, a few miles north, and his parents had donated the land for the cemetery.

"We don't use the church much anymore," said Walter. "But we have to be real careful of vandals. Someone stole the bell. I think I know who. Some collector guy. But I haven't got any proof."

I caught Greg's eye—himself an avid collector of prairie artifacts—but he didn't even blink, so perfect was his disguise as a photographer.

The three of us stood outside the door talking awhile. When asked whether he still attended church, Walter chewed his cheek for a moment, then placed his cap back on his head.

"Well, you know," he replied, adjusting the brim. "I like the idea of worship. But people always ruin it. So I guess I don't go as often as I should."

We passed through quiet towns—Danbury, Arabella—continuing east through a landscape of low hills along the easternmost edge of the Second Prairie Steppe. We stopped in a graveyard high above Thunder Hill Creek, where the sun finally broke through the clouds, illuminating the plains that stretched for miles and miles to the faint blue ridge of Duck Mountain. We spent the next few nights in Dauphin, MB, taking

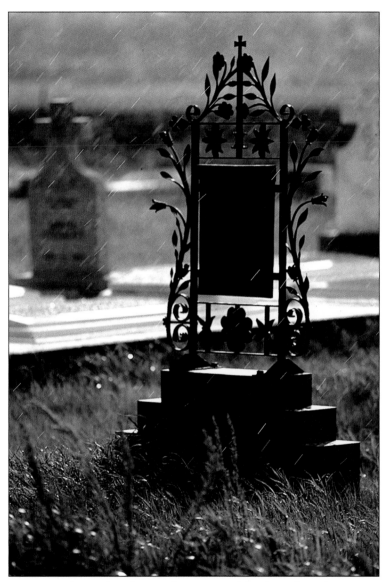

An iron marker in the White Beech cemetery at Thunder Hill Creek in eastern Saskatchewan. The base forms the three steps to Calvary: faith, hope, and love.

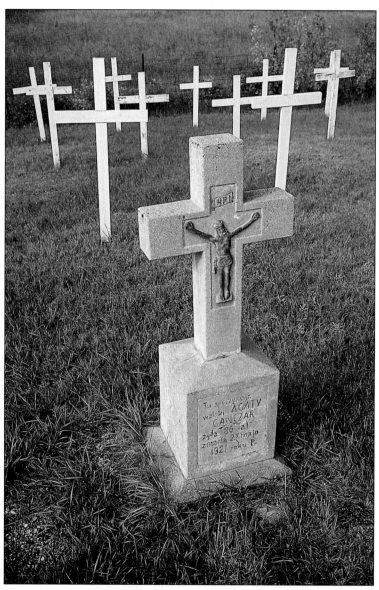

A cement marker in a cemetery near Riding Mountain, MB. The crucifix is of the Orthodox variety, with Christ's head unbent. Oddly enough, the image appears to be of an aged Christ, more like a sage. The whitewash has long faded from this old marker, leaving only the muted colour of the crucifix.

The Ruthenian Greek Catholic cemetery in the bush on a dirt road south of Winnipegosis, MB, where many original homesteaders are buried. During the winter of 1899 to 1900, many settlers lived in boxcars. Because they were short of blankets and food, several people died and were buried by the side of the tracks. As soon as the communities were able to situate their cemeteries, the bodies were exhumed and reburied. Most of the original wooden markers rotted long ago, but local craftspeople replaced them with traditional cement grave markers. This particularly unique example has heart-shaped ends.

day trips along the back roads through the surrounding countryside. Fall was in full swing, and the sky and fields were full of geese. It seemed a peaceful land, dotted with small towns like Ethelbert and Fork River. Eight thousand years ago it all lay beneath Lake Agassiz, an immense body of water that extended south into the Dakotas and east into Ontario. The remnant lakes still cover thousands of square kilometres. The highest point in Manitoba is an hour's drive from Dauphin—Baldy Mountain—and it's barely 831 metres (2700 ft.) above sea level. North from Dauphin is mostly bush and water, with a smattering of cropland carved from the stony earth.

Most of the farms were small and diversified, quite unlike the vast croplands farther east and south. Relic cemeteries lay like tiny parks or gardens in the bush.

On our second day out from Dauphin we came across the settlement corner at Mink Creek. There we found a Ruthenian Greek Catholic church and a small general store, where we stopped to buy some snacks. The shelves were crammed but orderly. There was a leather-covered bench across from the counter and a small table, obviously a local meeting place. The proprietor, Alfred Frykas, handed me a business card that announced him to be not only the local agent for hail insurance but also a manufacturer of dulcimers. Raised on the original homestead, he worked the land until 1975, when he built the store.

"My wife ran the place," he said. "But she's got cancer now. So I don't know how we'll stay open. She's over in Dauphin today having her teeth out."

While I stood talking with Alfred, Greg's quick eye

A cast iron grave marker in the Ruthenian Greek Catholic cemetery south of Winnipegosis, MB. This variety is common to all Prairie provinces, but they are usually upright on a cement base. Obviously, it fell from the base and someone stuck it into the ground. It now gives the eerie impression that Christ is rising from the very earth.

noticed a couple of wooden dulcimers stashed in the shadows on a top shelf.

"I used to play them at dances," said Alfred. "I even played for the CBC when they came around with their cameras looking for culture. But my shoulders aren't what they used to be."

Still, it didn't take much urging before Alfred brought down his favourite dulcimer and hammered out a few quick tunes. "My father taught me when I was about six," he explained.

After the concert we moved to the front steps and stood talking. A squirrel scampered across the fence and up a pole where it sat chattering at us.

"I think that's the same one that got zapped on a wire a few days ago," said Alfred. "It fell like a stone. I picked it up, but it came alive in my hand. Shot off like a bolt. Right up the church and over the dome."

A car drove by and Alfred waved. "Another pensioner," he said. "It's not like it used to be. Lots of land reverting back to the Crown. Kids don't use the community hall anymore. Or the church. They rent big weddings in town and have ten-dollar-a-plate dinners. Instead of everyone getting together and making the food. But, hey. We're all so rich, son of a bitch."

As we were getting in the car, I leaned over the roof to take a shot of him standing on the steps of his store. "Can't smile for you," he said. "Ain't got no teeth."

"Well," I said. "You sure seem happy enough."

"Hell," he said, smiling anyway. "You have to be happy."

That evening Greg and I lounged in the motel room, watching television and reading newspapers. The headline story was about a local murder. Two boys, seventeen and eighteen years old, had been charged with killing a seventy-two-year-old farmer. The farm was at the end of a long dirt road, and the sordid crime had gone unnoticed for several days. The two boys apparently spent those days drinking, and then brought a friend out to the farm to view the body. It was this third boy who directed the police to the crime scene, otherwise the murderers might have escaped capture. Thoughts of the tragedy lingered for days, imbuing the cemeteries with a certain profound sense of solemnity. I paid more attention to the names and dates on the markers, tarrying longer over those that bore evidence of lives cut short. The markers became more than merely cement or wood or iron, more than mere cultural artifacts. They reminded me of the people we had met on our journey, and how their inherent humour, often in spite of difficult lives, was an act of bravery.

We had reached the farthest point on our loop around the prairies and so started back on Highway 16 into Saskatchewan. But we didn't get any farther than Langenburg before taking to the side roads. The area was settled mostly by Germans in the late 1800s. Although the original settlers were mainly Lutheran, some German Catholics from Bavaria and the Black Sea had also homesteaded in the region. In 1891, several

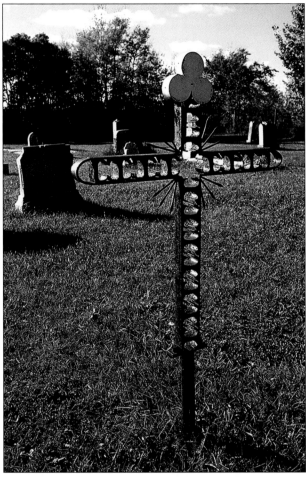

A wrought iron marker in the cemetery of the Lutheran church of Hoffenthal near Langenburg, SK. Germans settled much of the area in the late 1800s. Although the original settlers were mainly Lutheran, some German Catholics from Bavaria and the Black Sea also came here. This marker, in the middle of a Lutheran cemetery, is evidence of that minority.

Russian-German families arrived from Bessarabia. We passed a number of Lutheran and Baptist churches before coming to one that looked Catholic, but an onion-shaped dome had replaced the steeple. We then came upon the Lutheran church of Hoffenthal, where we got out to stretch our legs in the cemetery. It contained mostly austere markers, in keeping with the Lutheran faith, which rejected much of Catholic symbolism during the Reformation. So we were quite surprised to discover several iron crosses, especially the largest one, which ended with a trefoil at the top of the vertical shaft.

Tens of thousands of German-origin immigrants settled in Saskatchewan. Many came for the bargain farmland; and some, such as the Hutterites and Mennonites, were seeking political and religious freedom. Surprisingly, only a small minority of German immigrants came from Germany. Most came from the former German colonies in Russia, several Eastern European countries, and from the United States. Not only Catholics and Lutherans, but also Orthodox, Baptists, Adventists, and Jews arrived, speaking several different dialects and hybrid Germanic languages.

The first German colony to develop in Saskatchewan consisted of twenty-two families who homesteaded about eighty kilometres (50 mi.) north of Regina, in 1884. The colony was called New Elsass (New Alsace) and centred on the town of Strasbourg, in all likelihood named after the principal city of the German-speaking province of Alsace in France. Although the town's name originated from the French city, which was home to one of the Reformation's chief statesmen, Martin Bucer (1491–1551), the name may have arrived in Canada through the German communities near Odessa, in South Russia, which were settled by Alsatians in 1808. Although the core of the New Elsass colony was Protestant, including Lutheran and Baptist, some Catholic minorities settled on the periphery.

It was late afternoon on the final day of our journey when we found evidence of one such Catholic settlement, near Dysart. The church was no longer there, but a shrine had been erected commemorating the original parish. The shrine was backed by a 2.5 by 3.5 metre (8 ft. by 10 ft.), patterned iron grill announcing the name of the original settlement, Kronsberg. The shrine stood overlooking a wide expanse of prairie fields, with several artifacts arranged in front of the iron grill, including a statue of St. Henry. He was holding a miniature church, which reflected a certain time in Christian history when German rulers largely decided who should become pope. Henry was a pious ruler, who wanted nothing more than to retire to a monastery, but succumbed to the advice of the Abbot of Verdun, and retained his title. Henry and his wife lived in perpetual chastity. All of which might explain

how Henry came to be the patron saint of the childless and of those rejected by religious orders.

Other artifacts at the Kronsberg memorial included two small statues of angels, the church bell, and an iron cross with ends shaped like fleurs-de-lis. The iron cross was older than the grillwork—it may have come from the church or from a graveyard, and it was probably the work of a local blacksmith. But there was no doubting the fleur-de-lis—a favourite symbol used by blacksmiths, and one that had travelled far. Although the three prongs of the fleur-de-lis have come to represent the Trinity, the flower itself has a much longer history. Fleur-de-lis is another name for iris, one of the families of herbaceous flowering plants *Iridaceae*, of the order *Liliales*. Representations of the flower have been found in Crete dating back almost four thousand years. Greek myth has it that the lily was formed at the same time as the Milky Way, from the breast milk of Hera, Zeus's wife. There was also a Greek goddess named Iris whose duty it was to lead the souls of women to the Elysian Fields—the dwelling place of the blessed after death—thus the Greeks planted purple irises on the graves of women. One Christian tradition contends that the lily sprang from the tears of Eve as she left the Garden of Eden. And, in Christian art, the lily is an emblem of chastity, innocence, and purity.

We spent the last of the evening chasing the sun through a land of golden stubble fields, passing the miles in silence. We were road weary. But we kept to gravel roads, as if unable to admit that the journey was over. Somewhere northeast of Fort Qu'Appelle we came upon a broken stone house atop a rise, looking every bit like some ancient ruin. We spent an hour among the tumbled stones watching dark storm clouds gather on the eastern horizon. I leaned for a while in the doorway to relieve my casted foot and listened to the wind blow through the dry weeds.

Standing there at the front door of what had once been someone's house, I thought about the stones, and how they had been picked and hauled from the field and stacked one by one. Where were these people now, the souls who had walked through the same doorway day after day? They must have imagined their house would stand forever. Like the Dutch people in the small Saskatchewan town of Stenen, who set a boulder on a cement slab at the west edge of town. Attached to the boulder is a plaque reading: Stenen Means Stone; Like This Stone Stenen Will Be Here Forever. Well, the stone will outlast Stenen, of that there's no doubt. Rural populations are dwindling. Dreams are dreams, and stone is stone. Not far north of Stenen lies the bare granite back of the Canadian Shield, and even that stable interior balances on a sea of lava. Between that fiery sea and the sky is raised our daily bread. Forever is a long, long time.

Memories flooded through my mind. Two weeks of back roads and small towns, cemetery after cemetery. Crucifixes and crosses. Names and dates. Sad and abandoned churches. I thought about the iron crosses that we had seen earlier in the day. Were there more like them? A train sounded somewhere in the distance. I wanted to keep travelling. But winter was at our heels. The iron crosses would have to wait for another season.

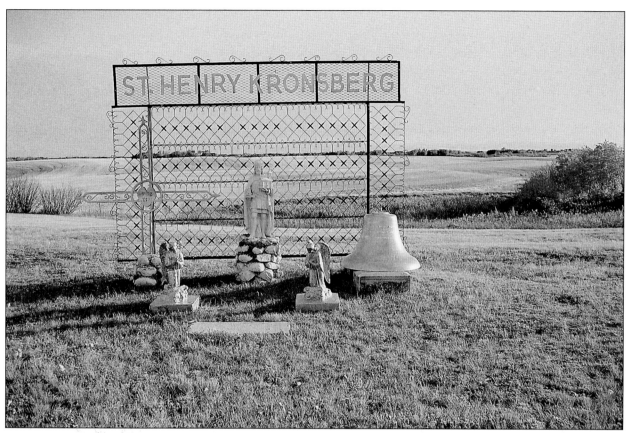

The Kronsberg memorial shrine, near Dysart, SK, includes a statue of St. Henry. He holds a miniature church, which reflects a time in Christian history when German rulers largely decided who should become pope.

A ruined stone house on a hill near the Qu'Appelle River Valley.

This sad enclosure, in the bush on the outskirts of the coal mining town of Mercoal, AB, raises only questions. The sign hung at the entrance reads: In Memory of Baby David, Baby Kaptyn, Baby Sereda, Annie Hanna, John Belair and veterans Wm Mitton, Wm Cook, Who Lie In Unknown and Unmarked Graves.

A STORIED LAND

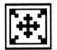 *Every cemetery marker represents a life once lived, and every life has a story. Sometimes markers fit within certain cultural traditions, and you can imagine each person as having been part of the surrounding community or ethnic group—the names and dates and symbols can be placed into a wider story. But sometimes the markers reveal only curious fragments, leaving a sense of mystery. Countless times I've stood before some grave marker, wishing it could talk—like the one for a nameless RAF veteran who died on 22 May 1942, which stands in the Padstow cemetery on Alberta Highway 43, near Sangudo. It is a crude cement marker, obviously fashioned by a local craftsman with an epitaph stamped into the cement:* A Man Of The World. *Did he die overseas? In battle? What does the epitaph mean? That he travelled through antique lands? Because there is no name, it would be difficult to discover the exact details of the man's life. But once embarked on such a course of discovery, there's no telling where it can lead.*

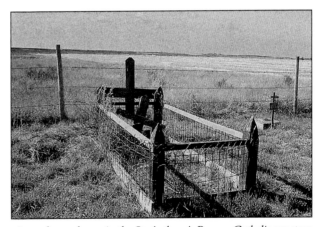

A wooden enclosure in the St. Anthony's Roman Catholic cemetery near Foremost, in southern Alberta. German Catholics settled the area and donated five acres of land for the church and cemetery. The community was known variously as Pleasant View, Windy Ridge, or Ninety-Nine (on account of its location in Township Nine and Range Nine). The ridge is still windy, and the view is certainly pleasant enough. But the church and the grave markers have long fallen to ruin.

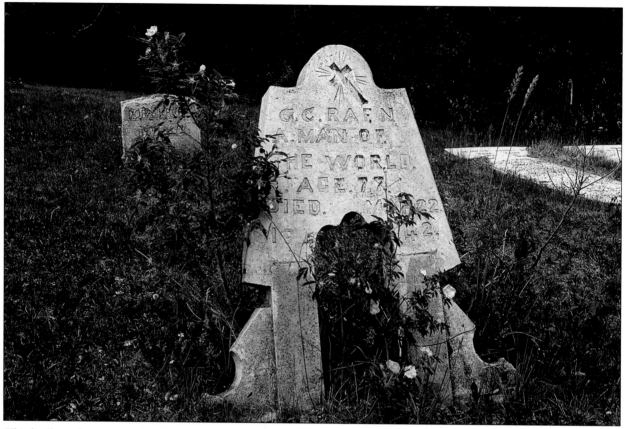

This locally made cement marker for a nameless RAF veteran who died on 22 May 1942 stands in the Padstow cemetery on Alberta Highway 43, near Sangudo. Not only is the arch of ancient origin, suggesting the passage through death to eternal life, but the rays around the cross harken back to ancient times and the worship of the sun.

The Captain Poulsen cemetery lies just north of the Alberta community of Cherhill. It is a small cemetery with a few modern markers and several broken cement slabs. Some of the older headstones have decayed, leaving only portions of names and dates. One crumbled epitaph has only two words left: *Baby, Old.* But up in the back corner nearest the road, partially overgrown in bush, stands a Greek cross. It has flared instead of trefoil ends and rests on a base in which a small niche has been hollowed out. Inside, a porcelain angel spreads her wings around two children. An old tin sign, which looks like a message board of some sort, is inset and painted over with the particulars of the deceased. But the paint and the sign are weatherworn, leaving a jumble of information. All that can be determined for certain is that the man's name was John and he was born in Prague sometime in the 1800s. He died in 1924.

I found the marker and the name of the cemetery so intriguing that I couldn't simply take a picture and leave it at that. A few phone calls led me to Caroline Martin, who runs a mixed farming operation with her husband. They live near the cemetery. At seventy years old, Caroline is still too young to have known Captain Poulsen, but she has tried to piece together some of his past. Although John Poulsen was one of the original homesteaders in the area, and donated the land for the cemetery, he died in 1918.

"There's no one left alive who remembers where he came from," says Caroline. "He was unmarried and lived alone. There is a rumour he was once a sea captain, a remittance man. But no one knows for sure. Some neighbours discovered his badly decomposed body lying in his cabin. He'd been shot. No gun was found, so we think he was murdered. But maybe he just got so lonely that he shot himself. Maybe someone hid

One interesting treatment of a Greek cross can be found in the Captain Poulsen cemetery, just north of the small Alberta community of Cherhill. The cement cross has flared instead of trefoil ends. Inside a hollowed-out niche a porcelain angel spreads her wings around two children.

the rifle so it wouldn't look like suicide. That way Poulsen could be buried in the cemetery grounds.

"It was a terribly lonely time. Homesteaders came for the free land, sometimes with nothing but the clothes on their backs. No tools, no money for seed. The men could hop freights and go look for work. But the women stayed behind. Sometimes they were pregnant and had to give birth alone in some crude cabin. Then they'd have to wrap the newborn and go out to saw wood.

"Cherhill was a long ways from anywhere. Sometimes people started walking and just died. In winter, the bodies froze stiff. Then you'd have to break their arms and legs to fit them in the coffin. And sometimes the train would bring bodies back. Husbands gone looking for work who died in the mines, or in some fracas in the city. There was a local man who used his wagon to collect coffins from the train station. He'd haul the bodies to the cemetery for burial. But sometimes the family couldn't afford a marker. So there's lots of unmarked graves.

"There's also a grave just beyond the fence for a man named Emil Maze. He worked at the store, which was also a boarding house and livery. He's said to have killed Mrs. Anderson, the owner's wife. Mrs. Anderson was found dead on the back stairs, shot. Emil Maze was immediately accused, and ran off into the bush. They hunted for him, but someone said Emil had a rifle, so no one looked very hard. They found him dead the next morning, leaning up against a tree. He'd shot himself. At least that's one story. They found him and the gun, but who's to say someone else didn't shoot him and plant the rifle?"

Apparently, Emil was a mild-mannered man, and there were rumours that he was particularly fond of Mrs. Anderson. By contrast, Mr. Anderson was harsh and cruel.

"A friend of mine told me that she once overheard her mother and some other women talking about it," says Caroline. "My friend's mother used to work there. She remembered Mr. Anderson coming to work one day with scratches on his face. He was angry, and said, 'There's going to be a clean sweep around here.' Soon afterwards, Mrs. Anderson was

found dead. And before the body was even cold, Mr. Anderson was busy going through all her drawers and papers."

So, we're left to believe what we will. Officially, Emil committed suicide, and was buried beyond the cemetery grounds.

As for the Greek cross marker, it belongs to John Wotypka. Although born in the Czech capital, Prague, John was a Slovak. He died in Cherhill in 1924, and his eldest son made the cement marker. There's a similar marker beside, but not for Wotypka's wife. It's for Joseph Placatka (1893–1920), who went to work in the coal mines near Edson, AB, when he was sixteen years old and came home paralyzed from an accident. He then spent eleven years in bed before finally dying. I guess John's son had cement enough for two markers, and he must have felt immense sympathy for the poor lad, Joseph.

The crosses also stand as cultural reminders of the Slovak people. Unlike many ethnic groups, the Slovaks didn't settle in any particular area, but scattered here and there across the prairies. Because Slovakia borders Austria, Hungary, Poland, and Ukraine, many Slovaks immigrated with other ethnic groups. Those who immigrated before World War I would have come from a Slovakia that was part of the Austro-Hungarian Empire, but, after October 1918, Slovakia announced its independence from the empire and became part of the new republic of Czechoslovakia. Still, calling a Slovak a Czech is like equating Irish with English. Czechs are mostly Protestant, while the Slovaks are devoutly Catholic. In 862, Prince Ratislav I sent a letter to Byzantine Emperor Michael III: "... We, the Slavs, a simple people, have no one to teach us the truth ..." The Emperor sent two apostles, Cyril and Methodius, and this Byzantine influence goes a long ways towards explaining why John Wotypka's son used the Greek form of cross on his father's grave.

Although Caroline Martin was able to provide much interesting information regarding the Captain Poulsen cemetery, she remains sad that the history of her community is passing from memory. But the prairie is a land of abandonment; a list of forsaken towns would read like a litany. The reasons are legion.

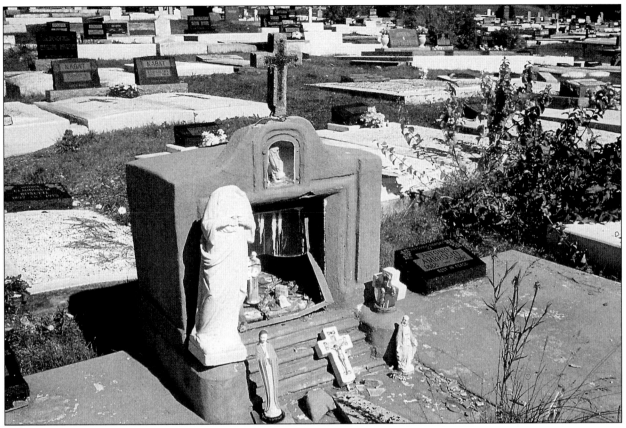

This broken shrine in the Blairmore, AB, Catholic cemetery is for Rosa Ambrosio (1889–1966). The miniature shrine resembles the kind of mausoleums found in Italian cemeteries, with designs based on ancient temples.

Some settlements were so fleeting that they vanished as if overnight. Not only can you determine the ethnic mix of a town or rural community by visiting its cemetery; the well-being of a community is always reflected in its graveyard. For a place to survive, it needs a cohesive force, like a church, or several descendants from an ethnic group. There are other factors, such as mineral resources and rail lines. And certain political factors: school districts, hospitals, county seats. Remove one or more of these and a community can shrivel in short order. Larger communities can afford to maintain their cemeteries, but many smaller communities rely on a single, dedicated soul to mow the grass and repair damaged markers. Often, once that person is no longer able to maintain the grounds, a cemetery will fall into disrepair.

Henry Swartz, of Melville, SK, was for many years the caretaker of the Lipton Hebrew cemetery. He relates the following story:

"In 1901 a group of single Jewish men came from Rumania to settle in the Lipton district, then known as the North-West Territories. They couldn't speak English, only Jewish and Rumanian. I understand that the government hired a Mr. Morrison to show where the boundaries of the homesteads were. Sometime between late fall or early winter one of the men was walking from one place to another and died. Whoever buried him got their directions mixed up and this made the start for the cemetery being in the middle of the road allowance, with RM 216 on the east and 217, Lipton, on the west. After several years the cemetery grew larger. When the second or third survey came through a diversion was made and the road came around on the west side. And that's how it is now.

"So the cemetery started in 1901 with the frozen man. And the last burials were one in 1950 and two in 1951.

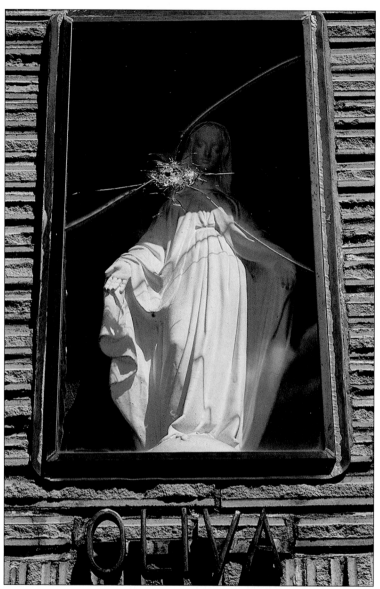

A brick mausoleum in the Blairmore, AB, Catholic cemetery. The coal mines of the Crowsnest attracted many people from Italy and parts of Eastern Europe.

In the early years they didn't even use coffins or rough boxes. The body was wrapped in a shroud and carried on the carrying table. They did their own undertaking. There was a little shack at the cemetery for heat to wash the corpse."

Henry's father and uncle were among the bachelors who arrived in 1901.

"Back in Rumania my father played drums in a band. But there were no bands out here. So he went into Winnipeg to look for work. But there wasn't any. He came back, but he was a lousy farmer. And then there was hail and drought. It was pretty discouraging for him. I took the place over in 1949."

By the time Henry buried his father in 1950, the Lipton Hebrew cemetery was overgrown with weeds. "You could only see the tips of the markers," says Henry. He spent the next twenty years looking after the place. "You know what the Jews say, dead is dead. Anyways, it was so overgrown my wife and I had to use axes and scythes to cut down the brush and weeds. We hauled out thirteen-and-a-half one-ton truckloads."

Henry moved into Melville in 1964, but he continued to look after the cemetery. In recent years his health has deteriorated, and he worries that the place will again fall into disrepair. The carrying table and one of the original wooden Hebrew markers can be seen at Yorkton's Western Development Museum.

It will not be long before museums are the only places to view relic cemetery markers. Most of the wooden ones rotted long ago, and many others were made from inferior cement. Those that remain are in danger of neglect. Some stand in the way of progress. Like everything else, rural cemeteries are being streamlined. There is a modern trend to allow only flat markers in the newer sections of cemeteries. As well, some cemetery boards don't allow anything loose to be left lying about. The reasoning is obvious—to keep maintenance at a minimum and to allow the lawn mowers easy access around the gravesites. I suppose it also dissuades vandalism, because there's nothing to knock down. But this trend towards low-maintenance cemeteries limits personalized expressions of memory or loss. It doesn't allow for homemade markers, or let people perform the special rituals that aid in the healing process. One woman told me that she left her young daughter's room just as it was for over a year before she collected all the plush animals and carted them to the gravesite. It helped her to come to terms with her daughter's death. So, we must be careful, in our rush to streamline everything, not to forget that cemeteries are for the living, too.

It was a warm late summer morning when I visited the Blairmore, AB, Catholic cemetery, a disorderly profusion of iron enclosures and sagging cement slabs set on a hillside up from the Crowsnest Highway. The coal mines of the Crowsnest have attracted many people from Italy and parts of Eastern Europe, and they brought their funerary customs with them. I noticed a brick mausoleum up near the treeline and headed for it. Inside lay the Olivias. Over the door, in a glass-faced niche, stood a plaster Marian figure. Starlike cracks radiated from a bullet hole in the glass near her head. I attached my camera to the tripod and was focusing carefully on the cracked glass when I heard footfalls directly behind me. I turned to find a man chewing on the long stump of a cigar.

"Kids," he mumbled, trying to light the cigar, his features shaded beneath a baseball cap. "Kids did that."

We stood talking for a few minutes, and then he offered to take me on a tour. His name was Tom Gibos, and he was seventy-four years old. He spent a lot of time in the cemetery, repairing and repainting the slabs above old friends. He showed me where his parents were buried, but he hadn't been able to locate two of his brothers. They died while Tom was fighting in France, and no one had marked the graves. His oldest brother was buried in the graveyard in nearby Coleman.

"Lost his arm when a chain came loose drilling a shaft," said Tom. "Bled to death because the man with him didn't know what to do."

We walked from grave to grave, row after row, while his little white mutt scampered over the slabs and through our legs. Tom talked about the cheap cement and explained how to repair it. His cigar kept going out, and his hands were always about his face trying to relight it. "Worked thirty years in the coal mines. Worked with him," Tom nodded at a marker. "And him, over there," he nodded again. We came to

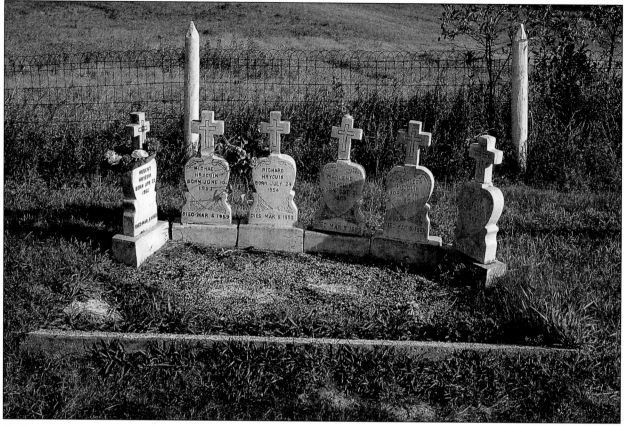

In the cemetery at Batoche, SK, there is a row of markers for the six Hrycuik children (aged from seven years to seven months) who died in a house fire.

a group of five ornate headstones and Tom stopped.

"Those there. They're brothers. See. The Marras. They were having lunch on a grassy spot down below the mine opening. It was the first sunny day in a week. Well, the slack gave way. Swallowed them in muck and left them down by the road."

Tom talked as if he were piecing together the past. "See the date on that one. August 9th, 1936. Same date as the one I showed you up the hill. And there's another down by the gate. They all died in the same car accident. That guy over there was driving." Tom led me to a fenced plot. "Martin. He was a braggart. Used to challenge circus toughs. Boxers and wrestlers. One time he bet a friend to swim across the town reservoir. Martin made it. But his friend died. Ten years later, on the exact same date, August 9th, Martin drove a car over a cliff. Took three people with him. All young. That grave next to Martin's. Anna Kubik.

She was a waitress. Had such pretty blonde hair. It was all torn and bloody."

Two hours passed before we reached the gate down by the road. Tom announced that it was time for his lunch. "I have a house. You can see it over there on the far side of town. I watch the cemetery through my binoculars. Lots of wildlife here." He pointed across a gully to the nearby United church cemetery, where several mountain sheep were lounging amid the headstones. There was a ram standing on a slab, still as a statue, watching us watch them.

And now, years later, I still imagine Tom watching the cemetery through his binoculars, or walking his little white mutt through the markers, battling the wind to keep his cigar lit. And the memory of Tom melds with all the other memories of places and landscapes and conversations among the dead. Some of the markers stand in memory like ghosts.

A small wooden cross in the Bear Creek cemetery in Grande Prairie, AB, marks victims of the 1918 Spanish flu epidemic. Because the ground at the regular cemetery was too hard, the poor souls were buried in jack pine country, where the sandy earth was easier to dig. The regular undertaker was serving in the army, and a hotel man was in charge of funerals. Unfortunately, he did not keep proper records. Fine forest grasses have covered the mounds.

Names echo in a dozen different languages. Tillie. Anna. William. Mother. Dad. The little ones. The Unknowns. The hundreds of symbols and patterns passed down through the ages, transformed over and over again. Crosses standing like arms outstretched. The very heavens brought to earth. I carry these thoughts and memories with me on every journey across the prairies. I watch out the window as the road falls away, through river valleys and coulees, small towns and villages—looking for domes and steeples and stands of dark evergreens.

In the same way that people are comfortable in certain places—a friend's home, a park, a tavern, a coffeeshop— I have become fond of certain routes across the prairies. Although each passage feels familiar, through the same intimate landscapes, there are always unexplored side roads to head down—untravelled tangents that inevitably lead to fresh discoveries, more pieces to place in the mosaic. One such route leads south from Edmonton, through the land lying along the Red Deer River. It's an especially familiar route for me, having travelled it in the days before my interest in cemeteries. Back then, my travelling companion was a millwright by the name of John Molyneaux. Travelling by pick-up truck or canoe, we spent many nights by campfires exchanging tales of days gone by, imagining ourselves to be retracing the routes of fur traders and missionaries. There were times when I thought John was a bit excessive in his desire to recreate the hardships faced by early explorers—times when he insisted upon using only three sticks to light a fire or to cut our own poplar poles for his huge, canvas tent, sometimes in the dark of night. But, I must admit, his stubbornness for authenticity made

Celtic crosses are surrounded with a circle. Some scholars believe this circle was derived from the Egyptian ankh. This cross, in the cemetery west of Olds, AB, has fallen from its base.

the experiences more memorable. And my travels with John certainly prepared me for various solitary journeys later on, camping in places such as Buffalo Lake, Willow Creek, or the badlands along the Red Deer River.

My usual route lay south past the old homestead, east to Highway 21, and then south again past towns like New Serepta, Hay Lakes, and Armena. It is a land of small lakes and low hills ridged in poplars. Many of the area's farmers are descended from Scandinavian settlers. Some town names clearly reflect the lineage—New Norway, Edberg—and out along the country back roads a few small wooden churches still survive. East from Edberg lies Driedmeat Lake, and the Battle River, once a favourite haunt of Métis buffalo hunters. Several old rail lines cut through the area.

Donalda is one of those whistle stops created in the early 1900s during the rapid expansion of the railways.

Almost one hundred towns were created in seven years, from 1906 to 1914. By 1915, Canada's railways had more mileage per capita than any other country in the world. The Canadian Northern Railway named Donalda in 1911, after a niece of the company's vice-president. Previously, the post office was called Harker. And, for four months in 1911, it was known as Eidswold.

The Donalda town cemetery lies just south of town near the tracks. And it was there that I found one of the most enigmatic markers I've ever come across. Sunk in the earth, almost overgrown with weeds and grasses, is a small cement tablet with no name or dates: simply the words, in metal letters—*Elevator Man*. Curiosity took me to town, where I inquired at the antique store, but they'd never seen the marker. They promised to ask around. But the Elevator Man remains a mystery. In answer to their inquiries, they were told: "If we knew anything more, we damn well

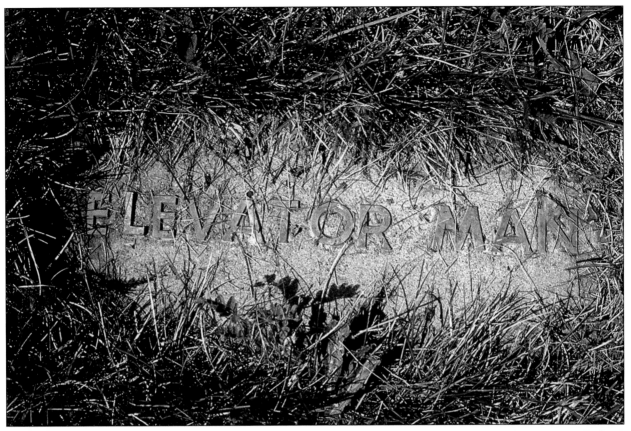

Did he come to town in a boxcar, or in a wagonload of workers? Did he ride in alone on a horse, or in a cart behind an ox? Was he found frozen beside the elevator, or crushed beneath a train? Was he Uncle Jack who went out West to never be heard from again? Did he promise to write when he found a place?

would have put it on the marker."

Someone in town remembered at least that the man either worked at, or operated, the town elevator. But how and why did he come west? The Elevator Man played a part in the history of Donalda, but now his small marker is almost grown over. He'll soon be entirely gone from memory—in a town barely two generations old. Once memory is gone, dust surely follows.

From Donalda, you can follow the rails south to Red Willow, where they angle west to Stettler and intersect with a CPR line. In 1905, Stettler was the centre of a German-Swiss colony and was called Blumenau. When the CPR came through in 1906, the town was renamed after Carl Stettler, one of the area's homesteaders. Many of the original settlers are buried in small cemeteries that can be found by driving the area's back roads.

One such cemetery belongs to the Estonian Association.

The chapel still stands. Although not much bigger than a small granary, its bright orange exterior is visible from a long ways off. The cemetery was established in 1906, when the Alberta government donated land for a church. Rudolph Hennel lives on a farm about twenty-four kilometres (15 mi.) south of Stettler. He's eighty-two years old. His grandfather came to Canada from Estonia in 1903, and Rudolph's parents followed in 1909.

"In the early days, the chapel was only used in summer," says Rudolph. "There was a Lutheran preacher who walked from Medicine Hat every summer. But he went back in the fall. So there was no church in the winter."

Rudolph's grandfather was a sailor who got a free trip across the Atlantic Ocean in a cattle freighter. When he left Estonia, it was part of the Russian Empire, which lies to the east. It's a northern country, one of the Baltic States. The actual origin of the Estonians is

The entrance gate to the Forestburg, AB, Public cemetery. The arch symbolizes the passing from death to eternal life.

lost in the complexities of human migration—some scholars believe that the Estonians are related to the Finns and Hungarians, others point to language similarities between the Estonians and the Tartars from southern Siberia. Regardless, by 1000, Estonia was a well-organized society of independent farmers.

Christianity arrived with German Catholic knights who defeated the Estonian farmers in 1193 and made them serfs. German landowners then seized the farming estates. The 1500s brought the Reformation, and many Estonian serfs converted to the Lutheran Church. Ivan the Terrible eventually defeated the Germans. Then the Swedes occupied the north, and the Poles took the south. By 1625 Sweden controlled the entire country, but the farming estates were still owned by Germans. Most Estonians remained landless peasants. The Russians eventually stormed back when Peter the Great decided that he wanted the seaports. And, from 1710 to 1918,

Estonia remained part of the Russian Empire.

Rudolph says that only about one hundred or so Estonians settled in the Stettler area. We can only imagine what it must have been like for them, trying to clear the stony land and raise crops in the clayey soil while their homeland suffered through yet another war. How did they feel when Estonia finally claimed independence in 1918? When the Russians invaded again in 1940 and then the Nazis in 1941? When the Soviets returned after World War II and the Baltic Sea was strewn with the bodies of refugees whose boats had been blown out of the water by airplanes and submarines? Over eighty thousand Estonian farmers were deported to Siberia.

Rudolph has never been to Estonia. Not surprising, considering that in its long history the small country has known only turmoil. In 1989, tens of thousands of Estonians joined hands to form a human chain across

A wrought iron marker in the Trochu, AB, cemetery for Louis and Anna Guilbert. The repeating motif of three circles symbolizes the Trinity.

their land, joining with citizens from Latvia and Lithuania, declaring their freedom from the Soviet Union. It was the same year that Rudolph retired from farming. One of his sons still lives on the original homestead, and a grandson will soon be the fifth generation to work the land. Modern farming techniques and fertilizers have tamed the clayey soil. "There's not many of us Estonians left around here," says Rudolph. "Some moved to Australia. Others went to the States. But we still bury the odd one." His daughter-in-law mows the grass and tends to the grounds. There are plans to restore the chapel.

In summer, you can stand in the cemetery and look out over the green fields. An occasional car may drive past. Most of the gravestones are simple, concrete markers. Some are topped with small crosses. But there is one intriguing monument—a statue of an upright female figure in a posture of mourning. In an urban

setting, she probably wouldn't be as striking. But set against a backdrop of prairie fields, her sadness seems to encompass the entire landscape. I imagine her mourning not for an individual soul but for the long ages of history that passed before people like Rudolph's grandfather finally found a home free of vassalage.

South of Stettler you pass into the land of the Red Deer River. To the west are the Knee Hills, where hundreds of small creeks braid down towards the river. The roads meander through small towns like Delburne and Lousana. Most of the cemeteries rest in quiet glades near the towns. There are dozens of small wooden churches—Anglican, Baptist, Lutheran, Roman Catholic, and Presbyterian—evidence of the variety of nationalities that originally settled the area. One of the most interesting groups was led by an aristocratic Frenchman named Armand Trochu, who, in 1903, started a ranching operation near the town that bears his

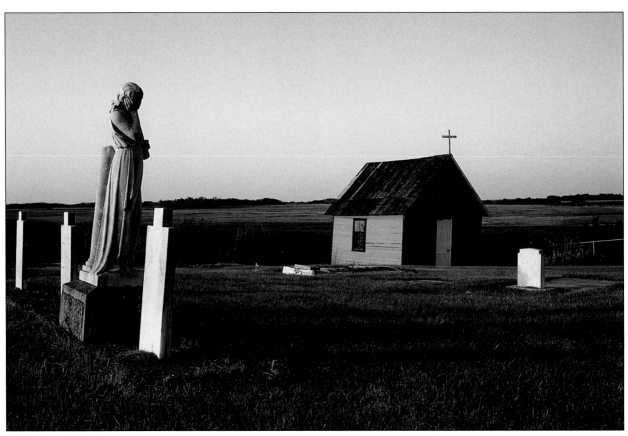

This modern version of Our Lady of Sorrows stands in the Estonian cemetery south of Stettler, AB. Her sadness seems to encompass the entire landscape.

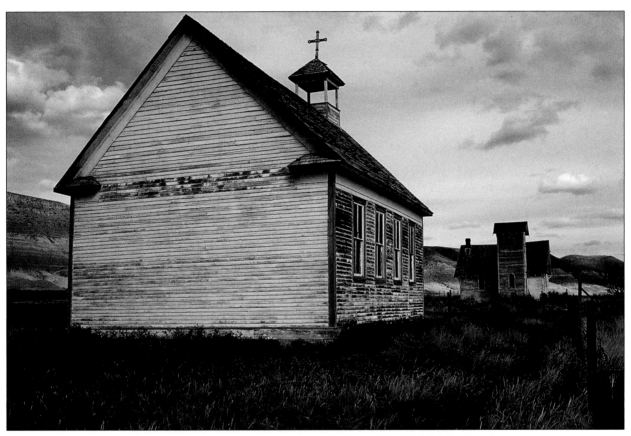

Two churches in what was once the town of Dorothy, southeast of Drumheller, AB. The Catholic church in the foreground is a schoolhouse renovated through the efforts of Reverend N.R. Anderson, pastor of Drumheller from 1934 to 1946.

A single, unmarked grave, just beyond the fence line behind the derelict United church in Dorothy, AB. Rumour has it that it's an Indian grave. But no one remembers a name, or how the grave came to be there.

name. The group included several cavalry officers. For ten years, the ranches grew and prospered, but, when Germany invaded France in 1914, most of the Frenchmen put on their uniforms and returned to Europe. The Kneehill county map reveals a few scattered quarter sections still owned by people with French surnames—Freire, Lemay, Debeaudrap. There's a wonderful wrought iron marker in the Trochu cemetery for Louis and Anna Guilbert, and, southeast of town, there's a section of land belonging to the Joan of Arc Ranch.

It was on a height of land nearby, where, in 1792, HBC surveyor Peter Fidler first caught sight of the Rocky Mountains. After spending that winter in the south with the Peigan, he returned through the Knee Hills in February of 1793 and made a discovery that would eventually determine much of the area's history: coal—coal to heat the homes and fire the furnaces of industry. Tons and tons of coal. Enough to warrant the building of hundreds of miles of tracks. And with the trains came men riding the freights. Thousands of hopeful souls looking for work—Italian, Chinese, Hungarian, Ukrainian, Polish, Belgian, French, Irish, Welsh.

Because miners were paid by the tonnage rather than a daily wage, they often put their safety at risk. Accidents were frequent, and deadly. In his memoirs, Reverend N.R. Anderson recalls his first visit to Drumheller. He arrived on a CNR train that wound through the valley of the Rosebud River, through Benyon, Wayne, and Rosedale. Piles of coal slack burned on the hillsides; an awful stench pervaded the air. He had come to bury four men killed in a mine explosion. The next day, the street outside the church resounded with the heavy tread of men arriving along the wooden sidewalks. After the funeral mass, the coffins were carried to the cemetery—a field devoid of vegetation, with four graves dug from the cold November clay, a sickly white bentonite mounded under a dull, grey sky. The Drumheller cemetery is now an oasislike expanse of lawn and bush, but some of the grave markers from those terrible days still stand.

Reverend Anderson eventually became the Drumheller pastor, a position he held from 1934 to 1946. He was a feisty Irishman, compassionate and tolerant. Because the Catholic church was only about a block from the tracks, when the train stopped to take on water, he found himself feeding and clothing a steady stream of vagrants. Most of the men moved on, but some stayed and took shelter in shantytowns built along the tracks, where they roasted in summer and froze in winter. As well as feeding and clothing the needy and performing last rites for coal-blackened miners, he was also known as the "church builder extraordinary." By renovating unused schools at small expense, and marshalling often reluctant volunteers, he managed to establish churches in several of the area's smaller towns. The one in nearby Dorothy still stands.

The townsite of Dorothy lies on bottomland in a bend of the Red Deer River, mostly badlands, with sparse grasses and sage. A stretch of road leading from East Coulee to Dorothy used to be the rail bed, along which steam engines hauled trainloads of coal. There are several relic buildings, including what was probably the blacksmith's shop, a store, and two abandoned churches—the Catholic church erected by Anderson, and a United church, both used by travelling priests.

The town is presided over by a derelict grain elevator. Like a gigantic tombstone, it can be seen from anywhere on the small plain. Cattle have worn tracks in the field around the elevator, and swallows and pigeons fly through the high open windows. A bridge joins the road north and south, but there used to be a ferry. Norm Pugh, a rancher who lives near the river, about a half mile from town, tells how people arriving all at the same time would wait together on the bank and swap stories. Now there's only the sound of occasional traffic across the bridge. There's also a single, unmarked grave beyond the fence line, a dozen or so yards from the deserted United church. All that remains is a mound of rocks. Norm told me it was an Indian grave. But no one remembers a name, or how the grave came to be there.

Still, it could very possibly be an Indian grave. The Plains Indians had various modes of burial. Some bodies were wrapped in buffalo robes and placed on the ground in a deep ravine or on the summit of a hill, then covered with dirt and rocks. Sometimes they tied the bodies into a bundle consisting of the dead

person's lodge and placed them on raised platforms, or in the boughs of a tree. The land south of the Red Deer River was once home to the Blackfoot Confederacy of Indians, who ranged freely between the Missouri and the Bow Rivers, sweeping their hunting grounds clear of all other tribes. Although the arrival of the vagrant Spanish horse dramatically altered the evolution of the Blackfoot, enabling them to trail the vast herds of buffalo, they still wintered in bottomlands where game was plentiful. If the snow became too deep, the Blackfoot would feed their horses on the inner bark of the cottonwood trees. Consistent with the folklore of many indigenous peoples, the waters of the creeks and rivers cleansed and purified. A morning plunge was ritual for a Blackfoot warrior, to make him tough and healthy, to strengthen him so that he could endure the cold.

Coming off the plains into a river bottom or prairie coulee is like dropping into another world—a world of cottonwood and willow. Owls and herons nest in cathedral groves and deer forage along the high banks. Imagine for a moment what it must have been like for the Blackfoot: a promise of abundance, of shelter. Many of the herbs used by medicine men could be found in the sheltering trees, named by the shapes of their leaves. And it was in these places where they often buried their dead.

One night I was camped in a creek bottom when a relentless wind came howling through the cottonwoods, crescendo upon crescendo, tearing fall-dry leaves from the branches. The tarp snapped over the cook table like claps of thunder. The wind raged as if it wanted to devour everything in its path. The walls of the dome-tent strained inwards, and I suddenly sensed that the wind was angry, that it wanted to get inside the tent. The sensation lasted for about an hour until the wind subsided to a steady blow.

I zipped open the flap of the tent and sat cross-legged at the door, wearing my sleeping bag like a cocoon. I was exhausted and breathless. A bright crescent moon shimmered unearthly in the clear sky, and the northern lights pulsated as if orchestrated by the wind. The cottonwood grove was strewn with leaves, and the night-dark branches reached out bare against the stars. After a while, my fear seemed foolish. The wind was no beast, I told myself, and it wasn't after me. Just then a twig snapped from somewhere nearby and an owl called from up the canyon. My scalp tingled. The sound of twigs breaking, as if someone were walking around and around the campsite, continued for several minutes. I closed the flap and lay in the centre of the tent, listening. Was it a ghost, an angry spirit? Or just a combination of natural forces that had spooked me? Maybe a deer. Who knows? I don't scare easily. Yet that night I felt a very real fear.

There are several old Blackfoot lodge tales that tell of ghosts appearing on the wind. And spirits often sounded like owls. There is a story about a warrior who was travelling alone one evening when he came upon a fallen tree. He propped up some branches and made a shelter. Then he built a fire and sat against the tree to stay warm. Just as he was dozing off, he heard something moving through the branches. He thought for a moment that an enemy had found him. But it was making far too much noise. When he looked towards the fire, there was a ghost sitting there, clothed entirely in white, with its face concealed. It was very tall and had bony legs, which it kept poking towards the frightened warrior.

"Go away," said the warrior. "Go away."

But the ghost moved closer. So the warrior grabbed the stick he had used as a fire poker and brought it down hard on the ghost's legs. Upon which the ghost instantly vanished. After a while, the warrior tried to sleep, but the ghost kept moving about the tree and crying like an owl. In the morning, while walking around the tree gathering firewood, the warrior came upon the skeleton of a man, and realized that, when the tree had fallen, so had the body. And thus the spirit could know no rest.

So even the land has stories to tell. Imagine how many trees once held the bones of the dead. And how many bones still lie scattered or buried on the prairies. Various prairie towns now stand in locations that were sacred to the original peoples of the West. A number of highways follow ancient migration routes, later retraced by fur traders and Métis freighters. Then settlers arrived, following the same routes. Often, the first land turned was

for a grave as these newcomers were buried where they fell. How many bones were turned back into the earth by settlers' ploughs? How many people have spread the ashes of their loved ones over the land?

My first trip through Dorothy was many years ago, on a swing through the prairies with John, my millwright friend. And several times during following years, I stayed in the town campsite. I've canoed past it twice. The first time was with my younger brother, Davey. We pulled to shore a few canyons downstream from Dorothy, at the mouth of Crawling Valley. Davey set his tent on a sandy knoll and sat before a campfire waiting for the full moon to come over a near rise. It was only a month since he'd tried to kill himself with whisky and pills. As I watched him that night waiting for the moon, he seemed happy to be alive, as if he'd finally shucked his demons. He died soon after that canoe trip, hit by a car while crossing the street in front of my home. So, the second time I canoed past Dorothy, it was to visit that spot in Crawling Valley—to spend a few hours alone with the memory of my brother. And, in 1996, on the first leg on my journey overseas, I passed through the town to toss his ashes over the bridge.

It has been said that you can't truly call a place home until you bury someone on the land, and then that place, the exact location, assumes a personal and intimate significance. Although there is a headstone for Davey in an Edmonton cemetery, I imagine his spirit flowing down the Red Deer River. I can still see him paddling his red canoe under that yellow bridge.

There is an old Blackfoot legend that tells of a creator being by the name of Napi, or Old Man. He is said to have formed his wife, Old Woman, from a ball of clay, and together they created the People. But, afterwards, they couldn't agree on how long to let them live. Finally, Napi suggested he toss a buffalo chip into the water and, if it floated, the People would die for four days and then live again. But Old Woman disagreed. She said she'd throw a rock into the water and, if it sank, the People would die forever. Well, of course, the rock sank to the bottom. Old Woman was satisfied, saying, "If the People lived forever, they wouldn't love one another."

There is a certain elegance to Old Woman's logic.

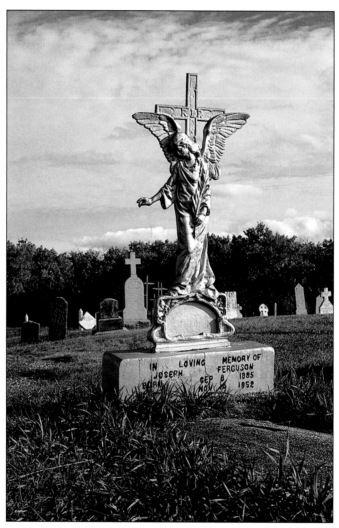

A cast iron angel in the Batoche, SK, cemetery in the last light of a fall evening. Such angels can be found in many Catholic cemeteries on the prairies. Joseph Ferguson was born in the fall after the Riel rebellion.

THE JOURNEY IS EVERYTHING*

➤—•❯—◦—❮•—◅

The act of driving through the open landscape of the prairies has become for me a form of pilgrimage—not surprising, I suppose, considering the subject of my explorations. My last journey took place in the fall of 1998. After so many years spent photographing cemetery markers, I wanted finally to learn something about who had made some of them. So I decided to focus on the wrought iron crosses that I had come across several years earlier. Because the most elegant examples are found in German Catholic cemeteries, I determined to search in the area around Leader, SK. My first order of business was to consult the maps. Even reduced to one-and-a-half inches for every two miles, the area represented by my collection of county maps could cover a tavern dance floor. Thankfully, all I needed for this trip barely covered the floor of the kitchen. Folded neatly, they fit snugly in my briefcase. The travel notes scribbled in the margins of the maps form a veritable anthology of curious though useful information. As artifacts, the maps have acquired an incalculable value—I'd be lost without them.

My second order of business was to gather my gear: bedding, clothing, writing supplies, cameras. But that was a simple enough matter. I knew exactly what I needed. My friend Harry Wilson and I have accompanied each other on several prairie excursions. We travel in Jimmy: a 1963 GMC one-ton, complete with a shack bolted to the frame. As high, wide, and long as the legal limit, the shack is constructed of two by fours and plywood, insulated, with tin sheeting over the roof. We hitch Harry's trike—part Triumph motorcycle and part VW Beetle—and haul it behind the rig. That way we can park the truck, call it home, and tour on the trike. Jimmy fits perfectly in the prairie landscape, looking every bit like it was resurrected from some farmyard. Harry can repair most any breakdown. It's a good thing, too, because he's had to change brake lines, a muffler, and reroute the wiring, all by the side of the road. A couple of years ago Jimmy blew a head gasket and the engine seized, so we spent four days in an alley in Paradise Hill, SK, replacing the engine. Appropriately enough, the replacement engine came

*(Montaigne, 1533–1592)

Jimmy—a 1963 GMC one-ton with a shack bolted to the frame. Jimmy is a story on wheels.

from a combine. A journey in Jimmy is like a poem to self-sufficiency.

We decided upon a leisurely first day and didn't leave Edmonton until late afternoon. We ambled east on Highway 14 only as far as the campground near Wainwright, where we played crib and talked until very late. Harry is an ex-trucker who now works in a laboratory, testing chemical effluent. But he also has a passion for prairie history and the natural environment. Our conversation ranged from ozone depletion to how the prairie ecology has been altered since the days of the buffalo herds—two friends, a deck of cards, and some stories. Even the coffee cup that I drink from has a story. Harry picked it up in Georgia back when he was trucking. The nameplate from his old rig hangs by the camper door: *Purple Hayes.* (Yes, the Hayes Company made the truck, and it was purple.) Harry's proud of his miles: "to the moon and back twice," he likes to say, and then points out that

"almost everything you see got here on a truck." But his long-haul days are over. Several years ago, he fell asleep at the wheel outside Carberry, MB, hit the ditch and broke his back. It was an ignoble way to end all those proud miles, and I rib him about it if he gets too far ahead in our crib tournament. We laugh, but it's not funny.

On that first night Harry retired after about the tenth game, and I went outside to get some air. I stood watching as a long freight train moved across the top of a distant hill. It was a new-moon night with a sky full of stars, and the train seemed to be passing across the very sky, its headlight shining out into space. An illusion—entire and incomparable. Pure prairie gothic. I couldn't think of anywhere else on the planet I'd rather be.

Morning dawned chill but sunny, and it was still early when we turned south on Alberta Highway 41, a narrow asphalt road called the Buffalo Trail, one of several north-south highways that follow ancient

A sad metal plaque for infant Ruth Benson in the Sunnydale cemetery near Oyen, AB.

migration routes. After a two-year hiatus from the prairies, I was experiencing the landscape with fresh eyes. The windshield was truly cinematic. We drove through a succession of shallow coulees—one minute the horizon line was defined by a willowed slope, and then suddenly it stretched across an implacable expanse of prairie. The highway continued south through rangelands with individual ranch holdings spanning well over twenty sections. The county map listed names like Crisp, Worobo, Guenther, and Wiechnik. And then, at the southernmost edge of Special Area #4, we passed several adjacent sections owned by R. Adams and L.R. Wilson. We wondered if they might be distant relatives, and we chuckled at the curious coincidence—being an Adams and a Wilson sitting adjacent to each other in the truck.

We continued south into the level landscape of the prairie dry belt. A landscape with a history of settlement described best in David C. Jones's book *Empire of Dust*:

"a life-sized saga of frothy boosterism, lightning expansion, and utter miscalculation—of drought, destitution, and depopulation." From 1870 to 1927, many people "proved up," sold out, and moved on. In fact, 41 percent of homesteaders withdrew before acquiring their patents. My county map showed only a few residences scattered here and there, some separated by eight or ten quarter sections. I remembered a few years back travelling those same long and lonely prairie roads. The margin notes recounted: Sunnydale cemetery (1910); Myrtle Weaver (died in childbirth); Evelyn Peterson (1917), who lived for eighteen days, and her twin sister who died at birth. Other names: Benson, Quain. Yet the map showed not one of those names as landowners of the property bordering the cemeteries. Several of the grave markers have no dates, merely the designation: "Early Days."

That evening we pulled into the small border town of Empress and parked Jimmy in the Peter Fidler

A view north across the centre mound of the medicine wheel near Empress, AB. Standing here, the land falls away all around; it feels as though you are at the centre of the world.

Campground, under the only mature tree on the flats—a hybrid cottonwood growing at least fifty-five metres (180 ft.) up from the flood plain. Rumour has it that it's over one hundred years old, a magical and unlikely number. Empress lies near the confluence of the South Saskatchewan and the Red Deer Rivers, a landscape feature that has determined the area's long history of human settlement. Plains tribes once wintered in the broad and sheltered bottomland. There is a medicine wheel atop the highest hill above the Red Deer River. From there you can see forever.

In 1800, Peter Fidler arrived at the forks and established Chesterfield House. The Hudson's Bay Company sent him out to barter for pemmican to provision the northern traders, but the Plains tribes were at their apogee and had little interest in trading. Still, Fidler's first inventory reads in part: 26 badgers, 158 wolves, 4570 grey foxes, 10 1/2 beaver, one common cat, and a whopping 2000 lbs.

each of bladder and back fat. But, because the tribes were constantly at war with one another, there was no end to his troubles. In 1802, after a band of Indians appeared on the opposite bank of the river singing loudly and carrying several scalps on a pole, Fidler and the other traders decided to quit the area.

Over the next couple decades there were a few aborted attempts by traders to establish in the same area, and there remained a settlement of Métis buffalo hunters at the forks, but it diminished with the herds. In May of 1883 the crew of the steamboat *SS Lily* tore down two of the three remaining houses for fuel wood. It wasn't until the late 1890s that several ranches were established. Finally, in 1914, with the arrival of the railway, Empress became a town—named after Queen Victoria, Empress of India. Now, eighty-five years later, the railway, the hospital, and the school have all closed down. In fact, some of the citizens of

A view of the Empress cemetery, which lies on a neck of land between the confluence of the Red Deer and South Saskatchewan Rivers.

Empress think it would be best to cease being a town and revert to village status. Once touted as the "Hub of the West," Empress is fading fast. Several steel piers from the dismantled railway bridge sit by the side of the road like so much junk, and the grain elevators have been demolished. The community cemetery is situated on a high wedge of flatland between the two rivers, a good fifteen minutes south of town. There lie those people who envisioned Empress would one day need a lot of elbow room to grow into a city.

I spent an afternoon in the Empress cemetery, walking among the grave markers, recording the names and epitaphs—the Campbells, Frasers, Knights, Dawsons, Pawluks, McMorrans, Lomows, Velcoffs. All *Gone But Not Forgotten, At Rest with Jesus, Gone to a Better Land*, or *Just Away*. What could I hope to know of these people? That Norris P. Stacey (1906–1985) must have been a pilot because he has an airplane etched onto his marker; that, halfway through her life, Edith B. Fraser (1895–1992) almost had a granddaughter named Marlene (06 Nov 1947), *A Bud to Bloom in Heaven*. Henrieta Plowman (1887–1955) was known by the affectionate nickname of *Dolly*. And yet one small marker has only a single name— Elmer (1886–1920). Why that sole name to mark those thirty-four years? Was it a first name or a last? And then there's Roy M. Rivers (1891–1985), *God Be with You, Till We Meet Again*. I recognized the line from a song—"happy trails to you, until we meet again"— by Roy Rogers and Dale Evans. I wondered whether the reference was intended? Roy Rogers, Roy Rivers?

I sat by the cemetery shed and leaned against the wall. All the quiet moments spent communing with the dead suddenly flooded through me—all the miles, cemetery after cemetery—as if for some reason I was meant to come to this place above the confluence of two rivers. I thought about that day in Dorothy when I had tossed my brother's ashes into the river, and wondered if they had reached the confluence yet, or if they had already continued on to join the ocean.

A few high, wispy clouds tossed across the blue sky, and the breeze blew warm with the smell of dry earth. Orange-backed butterflies flitted from one small yellow flower to another, and I remembered that butterflies are a symbol for the resurrection. My gaze fell upon the epitaph: *In The Midst Of Life We Are In Death*. Just then a piebald horse ranging on the other side of the cemetery fence raised its head and snorted. I stood and shook the cobwebs from my head and looked one last time across the tawny acre of grave markers. I felt strangely distant and yet wholly a part of the place. I walked slowly to the trike and sat for a few moments revving the engine. Not bothering with the helmet, I gunned the throttle and tore along the dirt trail, back to Empress, where my friend Harry was waiting to play another game of crib.

The Alberta/Saskatchewan border runs through the town of Empress. To the east, beyond the South Saskatchewan River, the land lies level to the Great Sand Hills—a place where the Blackfoot believed their souls travelled to after death. A landscape unlike any other on the prairies, the Great Sand Hills originated after the retreat of the glaciers, about fourteen thousand years ago. Although some of the dunes reach heights of fifteen to twenty metres (50 to 65 ft.), most of the area is defined by low knolls fringed in clumps of aspen, birch, and willow, interspersed with rose and saskatoon bushes, silver sagebrush, and prairie grasses.

The Blackfoot believed spirits lived much the same as the living. There are several legends telling of ghost camps and spirits that troubled anyone who wandered into the Sand Hills. The spirits are said to have communicated using weird whistling sounds. But, the

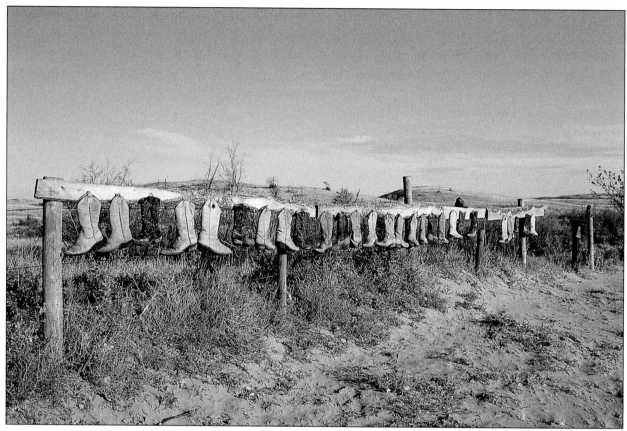

One rancher has nailed several cowboy boots to the top rung of a wooden fence. Hanging all in a row, they appear to be waiting for someone to claim them.

ghosts, it seems, are quiet now. These days the hills are used mostly for pasturing cattle. Interestingly, along a road leading south into the hills, ranchers still practise an ancient custom of the hunt by displaying, on entrance gates and fences, the antlers of slain deer and antelope. One rancher has nailed several cowboy boots to the top rung of a wooden fence. The old boots hang all in a row, like a memorial—like spirits.

The land around the hills was settled predominately by German Catholics. Beginning in 1908, they established a series of colonies: Mendham, Liebenthal, Krassna-Rastadt, Lancer, Prelate, and Prussia (now called Leader). The cemeteries in this area bristle with iron crosses, fashioned by blacksmiths who brought their skills with them from the Old Country. Each cross is different. Some are quite crude and obviously made from recycled iron. Others are elaborate and display a variety of motifs. Some are embellished with

palmettes, rosettes, quatrefoils, fleurs-de-lis, or hearts.

Iron was extremely rare in the ancient world and was used almost exclusively for decorative objects. For centuries, bronze was the metal of choice. Even in Roman times, iron was often dearer than silver. But iron gradually replaced bronze and copper in the making of tools and weapons, and the craft of the blacksmith became a "mystery," with its own trade secrets and traditions. Both northern and Mediterranean Europe had blacksmith gods: the Greeks and Romans had Hephaestus-Vulcan who forged the armour of Achilles and the shield of Hercules, the Scandinavians worshipped Thor with his great hammer and iron gloves. Blacksmiths fashioned weapons and armour and held the secrets of locks and keys for doors and coffers. The development of iron work as an artform is closely connected with the Catholic Church. Monasteries set up schools and workshops where the

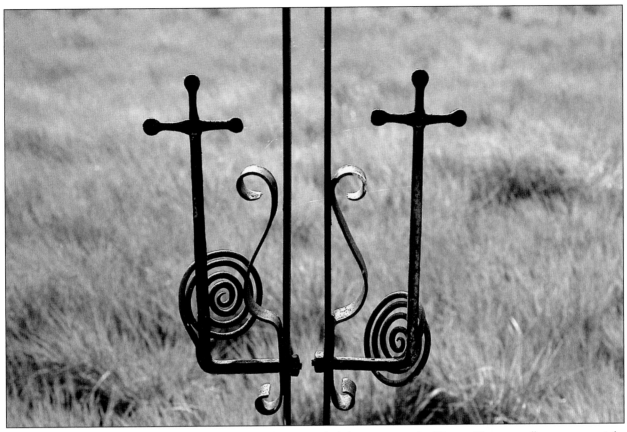

A design element near the bottom of an iron cross in the Bodo Roman Catholic cemetery south of Provost. The two small crosses represent the two robbers—one on Jesus' right and one on his left. The spirals can be interpreted in many ways, including as ancient symbols for the womb.

best craftspeople came to learn their trade. But, in the course of time, the prosperity and growth of towns gave lay craftspeople an opportunity to develop their skills. By the beginning of the thirteenth century, wrought iron work was flourishing, especially in Italy, Germany, and Austria. The iron crosses that stand on the prairies are evidence of this long history.

It was a Sunday several years ago when I first stopped at the Mendham Catholic cemetery in Saskatchewan. There I met Nick and Elena Jangula, who had travelled from Regina to tidy up the small garden plots over several of their relatives. Back when the Jangulas lived nearby, Nick was often called upon to dig the graves, but he couldn't remember all of them. We walked together to the edge of the cemetery where a man was shovelling soil from around a half-sunk, wrought iron cross. The man's name was Frank Marshall. I stood listening while Nick and

Frank discussed who had been buried where.

"No, no, no," said Frank. "Those seven over there. We got them figured out. But there's lots of kids buried under folks. Still births." Frank was the official caretaker, and he got most of his information from his seventy-two-year-old father who "doesn't get around, but still thinks real good."

"Our last name used to be Marsall," said Frank, leaning on his shovel. "But we changed it to Marshall." He was proud of his work. He'd already reclaimed several of the iron markers. "The wind blows dirt off the field and buries them. Some were nearly gone. Just the tops showing. I've repaired a few. I think they were made by some guy who moved around a lot."

I told myself that one day I'd return to find out who this blacksmith was. Although it took five years, I was finally keeping that promise. After a few days in Empress, a high ridge of cloud threatening from the

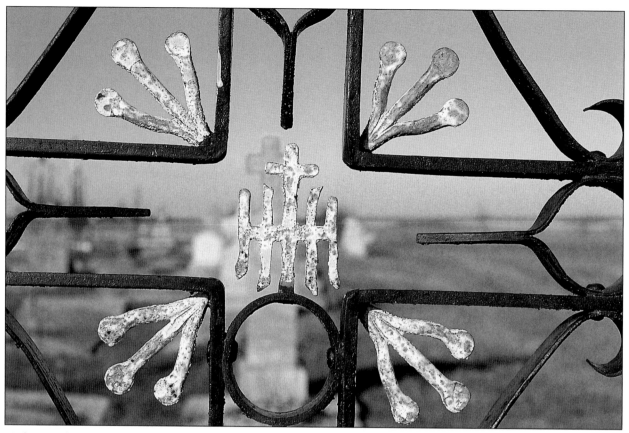

A close-up of the centre design motif from one of Stalanus Wingenbach's iron crosses in the Roman Catholic cemetery in Prelate, SK.

north finally settled over the prairies, and Harry and I decided that it would be a good day to be on the move. We crossed the border into Saskatchewan and headed towards Leader. Dark ragged clouds raced low beneath an overcast sky, and the horizon vanished. A brisk wind blew across the land, bringing the chill breath of winter. We stopped in a few cemeteries, but the light was too grey to allow for good photographs, so we continued to the town of Sceptre, where we visited the Great Sand Hills Museum. It was there, leaning against a back wall, that we found a wrought iron marker, with an interpretive plaque disclosing the blacksmith's name: Stalanus Wingenbach.

Wingenbach was born on 20 April 1885 in Krasna, a village in Bessarabia, a region squeezed between Rumania and the Dniester River, long disputed by the Turks and Russians. In 1885, Bessarabia was still reeling from a war in the Balkans, after which it had been annexed by the Russian Empire. Emigration to the

New World must have appeared mighty appealing. By 1917, when Stalanus finally arrived in Saskatchewan from North Dakota, he was part of a wave of seasoned farmers who took up residence in the already predominantly German area around Leader. The town, originally called Happyland, had been named Prussia in 1912. But, due to Canada's involvement in a war against Germany, the name was changed to Leader.

Although the blacksmith had been dead for several years, one of his sons lived in Empress. So, the following day, I found myself sitting at George Wingenbach's dining room table. As it turned out, I had met George a few days previously, when I had asked him for directions to the Empress cemetery. He remembered the trike, and we shook our heads and laughed at the odd coincidence. Then we spent a couple of hours talking about his father and sharing stories about the prairies.

In 1939, Stalanus quit farming and opened a blacksmith

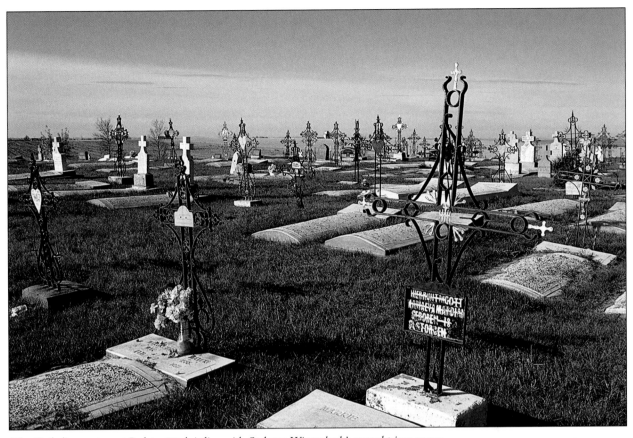

The Catholic cemetery at Prelate, SK, bristling with Stalanus Wingenbach's wrought iron crosses.

shop in Prelate, returning to the trade he learned from his father, who had been a blacksmith in Bessarabia. As well as making runners and strapping for sleighs, and repairing farm implements and machinery, Stalanus began making ornamental wrought iron crosses and selling them for about forty dollars each. George Wingenbach remembers how his father was always puttering. "He'd get some idea late in the evening and be gone to the shop for hours."

The iron cross in the Great Sand Hills Museum came from the grave of George's father-in-law. "When my wife's mother died, we got her a big, expensive stone. Her father was already buried, and we figured he should get one, too. So we replaced the cross and donated it to the museum."

George and his wife, Tillie, were born and raised on farms. They married in Moose Jaw and moved to Empress in 1948. George bought a dray wagon, two horses, a house, and a barn. He hauled coal and river ice. In 1951

he contracted with the village to haul water, and soon after that became fire chief of Empress.

"But the school closed," he remembers sadly. "And the hospital. The elevators came down just a few months ago. I almost cried that day. Lots of folks did."

George took us into the back yard and showed us the old fire engine, stored beside a shed. Hanging on the wall of the shed was a coal bucket, a hoe, and a meat hanger—made by George's father. Although he doesn't do any blacksmithing, George has inherited his father's creative bent. He carves whimsical objects and figures from wood.

"A person can't really retire," he said. "You've always got to be doing something."

By this time Jimmy was a genuine home. Harry and I were settled into our easy routines, and the comfort of urban life seemed some past extravagance we could mostly do without. Our next stop was Batoche. We'd been on our way there in 1995 when Jimmy blew a

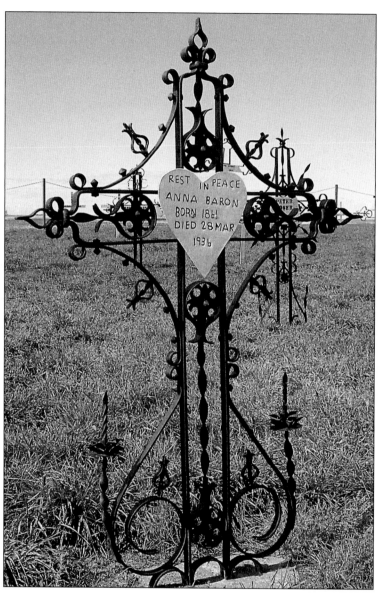

A wrought iron cross in the Mendham, SK, Catholic cemetery. Note Stalanus Wingenbach's signature use of quatrefoils and name plaque shaped like a heart.

A quatrefoil design used by Stalanus Wingenbach to decorate his iron crosses.

A gravesite for nine Métis killed at Batoche.

head gasket outside of Paradise Hill. We were on a tour of the Riel battle sites but turned back after replacing the engine. Going to Batoche was something we had been talking about for years. We ambled northeast on Saskatchewan Highway 7 to Saskatoon and spent the night parked in back of a small shopping mall. The following morning I took a walk along Broadway Avenue looking for someplace to check my email and have a long latte. Although Saskatoon is one of my favourite prairie cities, a veritable cultural oasis, I felt completely out of place in the hustle and bustle of a mid-week morning. Harry's wife often teases him about our journeys in Jimmy and has dubbed us the Edmonton Hillbillies. By the time we left Saskatoon, Harry and I were both glad enough to slip back into our roles.

We arrived in Batoche just after mid-day. Founded in 1871, it was named after a ferry operator, Xavier Letendre

dit Batoche. The townsite lies on the east bank of the South Saskatchewan River, a few miles upstream from the confluence, where it joins the North Saskatchewan. The land around Batoche is abundant with groves of poplar and willow. Several creeks meander through deep coulees down to the river. We parked Jimmy in an unmarked campground a mile south from the interpretive centre. Harry spent the time relaxing (in his real life he has five kids, a six to four job, and a mortgage), while I motored about on the trike surveying the lay of the land. I waited until evening, when the staff had gone home, and then visited the historic site. I nosed the trike down to the ferry crossing, and then up the rise to the mostly overgrown rifle pits, where the Métis made their last stand, while Riel, a self-appointed prophet, continued to pray for a miracle.

I reached the Batoche cemetery as the last of the day's sun broke below a ridge of clouds. Leaning

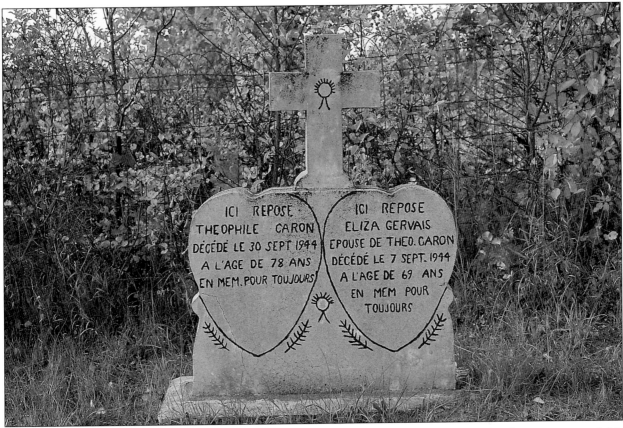

A double-hearted marker for Theophile and Eliza Caron (nee Gervais) who rest in the cemetery at Batoche. The unique sun symbol is decidedly Native and represents both the sun and a human form. Theophile was just nineteen years old when the battle of Batoche raged across this very cemetery. His wife, Eliza, was ten.

against the boulder marking Gabriel Dumont's gravesite, I looked down to the river. Braids of light shimmered on the water and fall gold cottonwoods rustled in the breeze. I heard the sound of water rippling over shallows in the wide bend. Crows called from somewhere in the valley, and flocks of geese settled in the bottomland. Here, I thought, was truly a place worth fighting for. The battle had actually raged across the cemetery grounds and down to the church. There's a gravesite for some of the Métis killed at Batoche, a fenced enclosure containing nine tall, weathered wooden crosses. One of my distant ancestors, Simon Fraser, was with a party of Métis horsemen who were on their way to Batoche. But Gabriel Dumont met them a few days after the defeat and told them the battle was already lost and to return to their homes. They were later stopped by the Mounties and asked about their activities, but claimed they were out

hunting wild horses. Or so the story goes.

I stood in the cemetery until dusk, watching the river. I felt as though I was standing at the nucleus of something. From Batoche you can follow the river upstream back to the Crowsnest, or veer south along the Milk and down to the Mississippi. The Bow leads to Calgary. Or you can head north from Batoche to the confluence and then upstream along the North Saskatchewan, past Edmonton to Rocky Mountain House. Fur traders used to haul their goods from Fort Edmonton to Fort Assiniboine and launch their canoes into the Athabasca, which leads eventually into the Arctic Ocean. No wonder the free roaming Métis hunters chose this location to settle.

The next day Harry and I visited the site of the Fish Creek battle, where Gabriel Dumont led his Métis cavalry against the forces of General Middleton. As we drove along in Jimmy I noticed the names on a

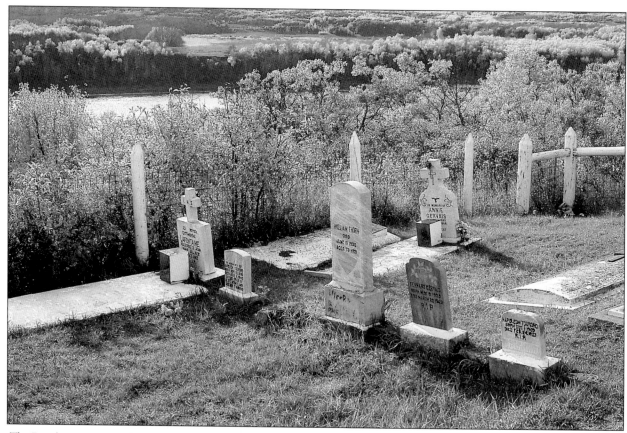

The Batoche cemetery, overlooking a wide bend in the South Saskatchewan River.

couple of roadside mailboxes—the Fidlers, then the Hryciuks—descendants of fur traders and Métis buffalo hunters now living side by side with descendants of settlers from Eastern Europe. We passed a deserted Catholic church and then a cemetery with several wrought iron crosses. They were decorated with hearts and stars and the rays of the sun. There were also anchors, and a single skull with crossed bones. It remained cloudy and cold all day, but the sky cleared a couple hours before dusk, and the night sky slowly filled with stars. It was easy enough to imagine one star flickering for each human soul.

Our final stop was the Battlefords. Yet another confluence of rivers. Of history. And of personal memories. After a detour to visit the Fort Carlton historic site, which turned out to be closed for the season, we zigzagged over to Highway 40. As usual, we arrived at our destination in the early evening. We parked Jimmy in the Eiling Kramer Campground, a short walk from the reconstructed Fort Battleford. We were grateful to find the showers open, and washed off some of the travel dust. In the morning, we walked along the ridge trying to guess where the besieged settlers hid their cattle from the marauding Cree warriors. We talked about how terrifying it must have been to watch from behind the stockade walls as the town of Battleford was sacked. Then we visited the nearby North-West Mounted Police cemetery where several victims of the Rebellion lay buried. Farther down the slope, there is a common grave for eight Cree warriors who were hanged for their part in the hostilities.

I still don't know why I saved the Battleford General cemetery for last. I can't count the number of times I've driven through the Battlefords, or skirted around, visiting nearby towns and cemeteries. Maybe I felt the place would be too unsettling. Several of my ancestors are buried there, including my father's parents. But they are from that branch of my family that fell away

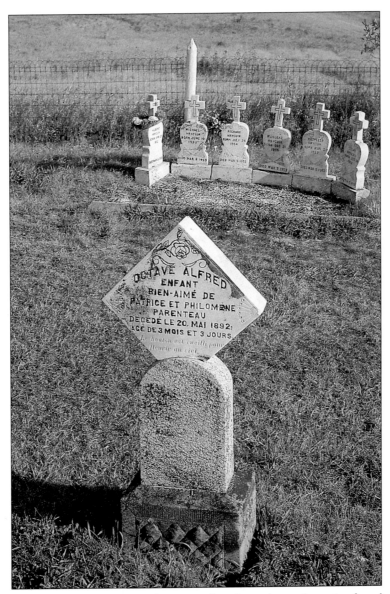

This grave marker in the Batoche cemetery is an interesting conglomeration formed of three separate headstones, for an infant who lived for only 3 mois et 3 jours.

A remarkable iron cross in the Roman Catholic cemetery near Fish Creek, SK. The simple design gives it a particularly elegant form. The pointed ends represent the Passion, and the three-pointed leaves are symbolic of the Trinity.

A small iron cross in the Roman Catholic cemetery near Fish Creek, SK. The tin stars are a unique motif. The various iron crosses in the cemetery have been painted black to protect them against the elements. They display a heartfelt attention to detail.

when my parents divorced. In the early part of this century, my paternal great-grandfather emigrated from Persia. I have a book written by my great-uncle, Reverend Isaac Adams, called *Persia by a Persian*, published in 1906. The pages are yellowed and worn, and the binding is split. Faded photographs depict my ancestors in traditional clothing. Two of the men have daggers held loosely in sashes about their waists.

Isaac Adams was born in northwest Persia in 1872, into a village of Nestorians, a Christian sect holding the doctrine that Christ was two distinct persons, divine and human. Isaac grew up herding cattle and working the fields and vineyards. But, as a Nestorian, he was taunted and treated cruelly by his Muslim overlords. He gratefully accepted the attentions of the Presbyterian missionaries and was educated in their schools. He immigrated to the United States in 1889 and attended a Presbyterian college in Chicago. After graduating as a medical missionary, he lectured in the States and Canada. It was during this time that he arranged to pay passage to Canada for his brothers Abraham, David, and Jacob, who stayed for a while in the East. In 1894 Isaac Adams returned overseas and thence back to Persia. His book relates several harrowing experiences, including being thrown into a Turkish prison as a suspected American spy. He managed to effect his release by arranging for a letter to be smuggled in a loaf of bread, all the way to

the American Embassy in Tehran.

In the fall of 1902 he spirited thirty-six fellow
Nestorians out of Persia. According to his own account,
he led this small group of refugees through the stony
valleys beneath legendary Mt. Ararat, and through
robber-infested regions into Russian territory. Several
people joined them along the way—including a hard-
hearted Turkish interpreter nicknamed the "Knife,"
and a homeless girl named Benusha. They straggled
into Hamburg weeks later, dog-tired and hungry, then
boarded a ship called the *Assyria*, which arrived in
Canada on New Year's Day, 1903.

Their first winter was spent in Winnipeg, and soon
after spring break-up they continued on to Saskatoon,
where they bought supplies. Following the old
Battleford trail, they made their way to the banks of
the North Saskatchewan River, and ferried across—the
first colonists to arrive at the spot that is now North
Battleford. After erecting their tents on approximately
the same site where the City Hall now stands, they
gathered in a clearing to sing a hymn praising God for
their deliverance from Persia. Then they set to work
building a large one-storey house constructed of
stones from the hillside with walls three-quarters of a
metre (2 ft.) thick. The surrounding homesteads were
immediately filed on. Isaac's brothers soon joined the
community. In 1906 Isaac returned to Persia and
brought out a further forty colonists, all of whom he
established before he finally made his home
in California.

As I walked through the cemetery, a sudden chill
wind rose and ripped the last yellow leaves from the
trees. Who were these people with whom I shared a
connection? The Odishaws. The Backuses. The Esaus.
The Georges. The Ramms. The Assyrians. Over the
years, separated by distance and cultural differences,
they have haunted the back reaches of my mind—a
heritage I write about, but never confront dead on.
Now I would have no choice.

I walked from grave to grave, noting that several of
the epitaphs were in Arabic script. But Elisha Jacob's
was in English: *Born Rizaiyeh, Azerbaijan, Iran; Came to
N. Battleford in Jan 07, 1907. Passed away Dec 17, 1963.*
Under which was written: *Receive Me To Thee One Worm.*

Although the epitaph seemed peculiar to me—having
one's soul compared to a worm—I understood that the
worm referred to the helpless larvae shut up in the
prison of its cocoon (symbolic of mortal existence), and
that the larvae had to pass through this utter
darkness and despair before it burst free.
"Fear not, thou worm, Jacob, and ye men of Israel;
I will help thee, saith the Lord ..." (Isaiah 41:14–16).

Then I came across the marker for one Abram Adams,
with the epitaph: *Born 1865 in Persia, murdered and burnt,
Sunday, July 11, 1915, 11 o'clock.* I recalled hearing various
stories. My aunt, Maria Bailey-Adams, a writer living in
Wivenhoe, England, relates that she grew up believing
Abram was murdered by his own wife. (Probably a story
told to scare little girls into behaving properly.) My
half-sister in Kelowna, BC, Sharon Adams, remembers
hearing that Abram was killed with a machete. But the
truth is even stranger. Abram Adams was in fact
Abraham Adams, my great-grandfather (they probably
used his Persian/Assyrian first name when they buried
him; Adams could originally have been Adam). My
uncle, Wilfred Adams, now a resident of Denver,
Colorado, has told me the official version.

"It happened on the original farm, about three
miles northeast of town. A hired man did it. Another
Assyrian. I guess it was over money. Though maybe
the man liked Abraham's wife. The man must have
been in a rage, because he butchered Abraham with
a plough shear, then set the barn on fire to hide the
evidence. Grandmother was apparently in town. They
deported the man back to Persia."

I've only met Wilf a few times—on those rare
occasions in summer when we both happened to be
visiting my father. I barely knew my father, Stanley
Adams. He was born in North Battleford, the son of
Paul Adams, one of Abraham's boys. My father was
born poor. I have a picture of him as a scrawny kid
proudly clutching his day's catch of rabbits. He
learned to play trumpet in the Salvation Army Band
and wanted to be a jazz musician, but instead he
became a chartered accountant and, finally, a land
speculator. He put his heritage behind him and
refused to acknowledge that he was the grandson of
poor, Old World settlers. He envisioned himself a

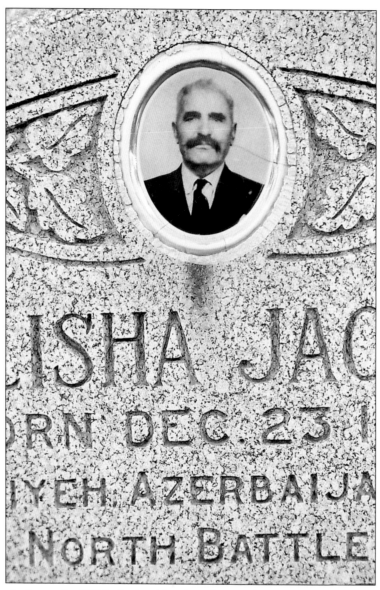

A photograph of Elisha Jacob, a Nestorian who arrived in North Battleford with Isaac Adams. Elisha's epitaph reads: Born Rizaiyeh, Azerbaijan, Iran; Came to N. Battleford in Jan 07, 1907. Passed away Dec 17, 1963. *Under which is written.* Receive Me To Thee One Worm.

wealthy businessman, as if it might erase the stigma of growing up impoverished. In less than half a generation—six pages in the photo album—he grew from a little boy hunting rabbits for dinner into an upwardly mobile land developer. Like my grandmother, he drew a veil over his past.

All in all, he made too much money for his own good and drank excessively. He built a magnificent house of stone and cedar overlooking Kelowna, BC. Near the end of his life he had several pictures from Isaac Adams's book enlarged and set in fancy frames. He hung them on the walls of his dining room. Finally, far enough removed from his sorry childhood, he was ready to reclaim his heritage. He'd sit at the head of his long dining room table under the crystal chandeliers, brandishing a glass of whisky, and tell his guests that he was descended from Persian royalty. He liked to tell a story about how one of his ancestors, a Persian prince, could blast his name into a wall shooting two pearl-handled pistols from thirty paces.

We hardly ever agreed on anything, but sometimes in the fall we'd go hunting—for some reason we wouldn't argue then. He was a skilled hunter, wily and sure. We'd drive into the low mountains east of Vernon, BC, and spend a few days tracking game. We spoke sparingly, walking through the fall forests, with October winds through the tall trees making sounds like a thousand creaking doors. Our first breakfast was always bacon, eggs, and hashbrowns. Any remains were used with dinner, along with a can of tomatoes, a green pepper, onions, and some hamburger. We'd leave the extra food overnight in the cast-iron frying pan. Our next breakfast was thawed leftovers served as a goulash with eggs. The concoction grew and diminished with each meal. In the evenings he'd play his trumpet and we'd share a bottle of Canadian Club until the night was cold. One night we stood in our long red underwear down by a lake, while he played his trumpet for the loons. He died years ago. I think of him most when the leaves are falling, and I know my autumn longings stem from those hunting trips.

The next morning Harry and I left Battleford and headed Jimmy east back to Edmonton. The autumn colours had faded to a drab brown. Near Marsden, SK,

we passed an alkali lake with scrub brush and fences caked white. Winter would soon transform the whole of the prairies into a desert of snow, with days when it would be warmer six feet under the earth. I watched out the window as the landscape fell away. It felt good to be moving.

We crossed the border into Alberta on Highway 14, and, upon reaching the junction with the Buffalo Trail, had completed our wide circuit of the prairies. Continuing west through Wainwright, the road soon cut into the valley of the Battle River, and then back onto the level parklands. Ahead lay a string of small towns spread out every twenty miles or so. At Kinsella, we passed a monument by the side of the tracks to Shayne Linley Redford, a twenty-seven-year-old CNR employee killed at the crossing in 1991. Someone had used painted-white rocks to spell his name on the face of a low embankment, in capital letters SHAYNE.

It was familiar territory. I spread the Beaver County map out wide and slowly traced the back roads. My pencilled lines and arrows marked the cemeteries: God's Acre, Golden Valley, Kopernick, Wowedina. A circled "x" identified the site of the Bardo Zion Lutheran church, built by Norwegian settlers in 1908. My notes told me that lightning destroyed the church in 1921. It was rebuilt in 1922 and lasted forty-three years before being levelled by lightning once again. The congregation finally quit the countryside and erected a church in Tofield. In the fading evening light I read the margin notes, some written ten years past: "picture a man with a horse hauling a boulder from the earth, the chain stretched tight—imagine the mass of stone." And, up in the top corner of the map, "Coyote Auto Wreckers, Aug. 10/94, return for shot in better light." I folded the map and placed it on the floor, looking up just as we breezed through Shonts, where someone has painted a name-change high on the abandoned elevator: Dirty Shorts.

It was late when we reached Edmonton's city limits. Yard lights blinked all around in the black distances. Harry turned the rig west on Ellerslie Road, and we drove along with the windows down.

"Jimmy sure likes cool evenings," he said.

I leaned back and stretched my legs against the

floorboards, feeling the throaty vibration of the straight block six-banger—the big flywheel giving it the strength of an ox.

"Runs like a dream," I agreed.

"Right out of a combine," said Harry, tapping his fingers on the dash.

He was wearing his grandfather's sweater. The man had been a farmer, well on his way to establishing a successful mixed farming operation. But, on the evening of 18 June 1932, he was killed by a bull. As Harry's father tells it: "It attacked right at the bullpen door and carried him on its head at full speed through the wall at the far end of the barn." The death left Harry's grandmother to care for a family of six kids, plus one on the way. Harry keeps the sweater in Jimmy and wears it only occasionally. It's a link to his prairie past and gives him comfort. He has already outlived his grandfather by several years.

The last few miles passed quickly, and the bright lights of the city dulled the stars. As we idled up to the 50th street intersection, Jimmy's headlights washed across a church. It was the same church my family used to pass on those Sunday trips out to the homestead. Somewhere nearby my grandmother would stop for brown eggs, and at another for fresh cream and butter. Although the homestead was sold soon after she died, Pearl Smith's ashes still lay buried on the property in a spot near her beloved berry trees. Her small travelling case is a perfect fit for my camera gear. As Jimmy turned north into the city, I smiled at the memory of the little boy at the loft window imagining the barn to be a ship on the seas. I thought: the journey is everything. And I wondered where I'd end my days.

BIBLIOGRAPHY

Abramovitz, Anita. *People and Spaces*. New York: Viking Press, 1979.

Adams, Isaac Rev. *Persia by a Persian*. London: Self-published, 1906.

Allan, Iris. *John Rowand, Fur Trader: A Story of the Old Northwest*. Toronto: W. J. Gage, 1963.

Aries, Philippe. *Images of Man and Death*. Cambridge, Massachusetts: Harvard University Press, 1985.

———. *Western Attitudes Toward Death: From the Middle Ages to the Present*. Baltimore: Johns Hopkins University Press, 1974.

Baggley, John. *Doors of Perception: Icons and Their Spiritual Significance*. New York: St. Vladimir's Seminary Press, Crestwood, 1987.

Barry, Iris. *The Prentice Hall Concise Book of Archaeology*. Scarbourgh, Ontario: Prentice Hall Canada, 1981.

Bean, George Ewart. *Turkey Beyond the Maeander*. New York: W. W. Norton and Co. Ltd., 1980.

Berry, Gerald Lloyd. *The Whoopup Trail*. Edmonton: Applied Art Products, c. 1953.

Bevington, Helen. *The Journey Is Everything: A Journal of the Seventies*. Durham, North Carolina: Duke University Press, 1983.

Brado, Edward. *Cattle Kingdom: Early Ranching in Alberta*. Vancouver/Toronto: Douglas & McIntyre Ltd., 1984.

Burnet, Jean R., with Howard Palmer. *Coming Canadians: An Introduction to a History of Canada's Peoples*. Toronto: McClelland & Stewart, 1988.

Butler, Sir W. F. (William Francis). *The Great Lone Land: A Tale of Travel and Adventure in the NorthWest of America*. Toronto: Macmillan, 1910.

Byrne, Venini, ed. *From the Buffalo to the Cross: A History of the Roman Catholic Diocese of Calgary*. Calgary: Calgary Archives and Historical Publishers, 1973.

Campbell, Marjorie Wilkins. *The Saskatchewan*. Toronto/Vancouver: Clarke, Irwin & Company Ltd., 1965.

Curl, James Stevens. *A Celebration of Death: An Introduction to Some of the Buildings, Monuments, and Settings of Funerary Architecture in the Western European Tradition.* New York: Charles Scribner's Sons, 1980.

Czuboka, Michael. *Ukrainian Canadian, Eh?: The Ukrainians of Canada and Elsewhere as Perceived by Themselves and Others.* Winnipeg: Communigraphics/Printers Aid Group, 1983.

Dempsey, Hugh A. *Big Bear: The End of Freedom.* Vancouver: Douglas & McIntyre, 1984.

Di Stasi, Lawrence. *Mal Occhio (Evil Eye), the Underside of Vision.* San Francisco: North Point Press, 1981.

Dury, Carel J. *Art of the Ancient Near and Middle East.* New York: Harry N. Abrams Inc., 1969.

Erasmus, Peter. *Buffalo Days and Nights.* Calgary: Fifth House Publishers, 1999.

Etlin, Richard A. *The Architecture of Death: The Transformation of the Cemetery in Eighteenth-Century Paris.* Cambridge, Massachusetts: Massachusetts Institute of Technology Press, 1987.

Ewers, John C. *The Blackfeet: Raiders of the Northwest Plains.* Norman, Oklahoma: University of Oklahoma Press, 1958.

Ewing, Sherm. *The Range.* Missoula, Montana: Mountain Press Publishing Company, 1990.

Galbraith, John S. *The Little Emperor: Governor Simpson of the Hudson's Bay Company.* Toronto: Macmillan of Canada, 1976.

Grant, Michael. *The Etruscans.* New York: Charles Scribner's Sons, 1980.

Grimal, Pierre, ed. *Larousse World Mythology.* London/New York/Sydney/Toronto: The Hamlyn Publishing Group Ltd., 1971.

Grinnell, George Bird. *Blackfoot Lodge Tales: The Story of a Prairie People.* Lincoln, Nebraska: University of Nebraska Press, 1962.

Hall, James. *Illustrated Dictionary of Symbols in Eastern and Western Art.* New York: HarperCollins Publishers, 1994.

Hastings, Max, ed. *The Oxford Book of Military Anecdotes.* New York: Oxford University Press, 1985.

Hendrickson, Paul. *Looking for the Light: The Hidden Life and Art of Marion Post Wolcott.* New York: Knopf, 1992.

Herm, Gerhard. *The Phoenicians: The Purple Empire of the Ancient World,* trans. Caroline Hillier. New York: William Morrow and Co. Inc., 1975.

Herodotus: The Histories. Everyman's Library Edition. Toronto: Knopf, 1997.

Holy Bible (New and Old Testaments), Revised Standard Version. New York: Division of Christian Education of the National Council of Churches of Christ in the United States, Thomas Nelson & Sons, 1952.

Howard, Joseph. *Strange Empire: Louis Riel and the Metis People.* Toronto: James Lewis & Samuel, 1974.

Hunchak, N. *Canadians of Ukrainian Origin* (Series No. 1 – Population). Winnipeg: Ukrainian Canadian Committee, 1945.

Huyda, Richard J. *Camera in the Interior: The Assiniboine and Saskatchewan Exploring Expedition.* Toronto: Coach House Press, c. 1975.

Janson, H.W. *History of Art,* 3rd ed. New York: Harry N. Abrams, 1986.

Jones, David C. *Empire of Dust: Settling and Abandoning the Prairie Dry Belt.* Edmonton: University of Alberta Press, 1987.

Kane, Paul. *Wanderings of an Artist Among the Indians of North America from Canada to Vancouver's island and Oregon through the Hudson's Bay Company's Territory and back again.* Edmonton: Hurtig Publishers, 1968.

Kovacs, Martin L., ed. *Roots and Realities among Eastern and Central Europeans.* Edmonton: CEESAC (Central and Eastern Europeans Studies Association of Canada), 1983.

Laxalt, Robert. *In a Hundred Graves: A Basque Portrait.* Reno, Nevada: University of Nevada Press, 1972.

Lehmann, Johannes. *The Hittites: People of a Thousand Gods.* New York: The Viking Press, 1975.

Lempriere, J. *Lempriere's Classical Dictionary: Containing a copious account of all the proper names mentioned in ancient authors; with the value of coins, weights, and measures used among the Greeks and Romans; and a chronological table.* New York: George Routledge and Sons.

Lucey, Donna M. *Photographing Montana, 1894–1928: The Life and Work of Evelyn Cameron.* New York: Knopf, 1990.

MacGregor, James G. *A History of Alberta.* Edmonton: Hurtig Publishers, 1972.

——. *Peter Fidler: Canada's Forgotten Explorer, 1769–1822.* Calgary: Fifth House Publishers, 1998.

Mackay, Douglas. *The Honourable Company: A History of the Hudson's Bay Company.* Toronto: McClelland & Stewart, 1949.

Massa, Aldo. *The Phoenicians.* Barcelona: Editions Minerva, 1977.

May, Rollo, ed. *Symbolism in Religion and Literature.* New York: George Braziller Inc., 1961.

McClintock, Walter. *The Old North Trail: Life, Legends and Religion of the Blackfeet Indians.* Lincoln, Nebraska: University of Nebraska Press, 1968.

Millar, Nancy. *Once Upon a Tomb: Stories from Canadian Graveyards.* Calgary: Fifth House Publishers, 1997.

Moon, Beverly, ed. *An Encyclopedia of Archetypal Symbolism.* Boston: Shamhala Publications Inc., 1991.

Norwich, John Julius. *Byzantium: The Apogee.* New York: Knopf, 1991.

——. *Byzantium, The Decline and Fall.* London: Viking, 1995.

Rayburn, Alan. *Dictionary of Canadian Place Names.* Don Mills, Ontario: Oxford University Press, 1997.

Rees, Ronald. *New and Naked Land: Making the Prairies Home.* Saskatoon: Western Producer Prairie Books, 1988.

Robins, Don. *The Secret Language of Stone.* London, Covenant Garden: A Rider Book, Century Hutchinson Ltd., Brookmount House, Chandos Place, 1988.

Shaw, Charles Æneas. *Tales of a Pioneer Surveyor,* ed. Raymond Hull. Introduction by Norman Aeneas Shaw. Don Mills, Ontario: Longman Canada, 1970.

Shillington, C. Howard. *Historic Land Trails of Saskatchewan.* Vancouver: Evvard Publications, 1985.

Thomson, George. *The Prehistoric Aegean: Studies in Ancient Greek Society.* London, Covenant Garden: Lawrence and Wishart, 1978.

Toynbee, J.M.C. *Death and Burial in the Roman World.* Baltimore & London: Johns Hopkins University Press, 1971.

Turner, Frederick. *Beyond Geography: The Western Spirit Against the Wilderness.* New York: Viking Press, 1980.

Walker, Barbara G. *The Crone: Woman of Age, Wisdom and Power.* New York: Harper and Row, 1985.

Willock, Thomas. *A Prairie Coulee.* Edmonton: Lone Pine Publishing, 1990.

Wunderlich, Hans Georg. *The Secret of Crete.* New York: MacMillan Publishing, 1974.

Zimelli, Umberto, and Giovanni Vergeris. *Decorative Ironwork.* Middlesex, England: The Hamlyn Publishing Group, 1969.

RECOMMENDED WWW SITES

Ancient World Web

http://www.julen.net/ancient/

A site designed by Julia Hayden, chock full of links to ancient history.

Association for Gravestone Studies

http://apocalypse.berkshire.net/ags/ags.shtml

A nonprofit organization, the Association for Gravestone Studies was founded in 1977 for the purpose of furthering the study and preservation of gravestones. AGS is an international organization with an interest in grave markers from all periods. Through its publications, conferences, workshops, and exhibits, AGS promotes the study of gravestones from historical and artistic perspectives.

Canadian Heritage Information Network

http://www.chin.gc.ca/e_main_menu.html

"A gateway to museums, galleries, and heritage information in Canada and around the world."

Catholic Online Saints Index

http://saints.catholic.org/stsindex.html

Dictionaries, Encyclopaedias, Almanacs

http://library.adelaide.edu.au/gen/dict.html

Offered by the University of Adelaide, Australia.

Dictionary of Phrase and Fable

http://www.bibliomania.com/Reference/PhraseAndFable/index.html

A browser's delight. This First Hypertext Edition is taken from Dr. Brewer's substantially revised and extended edition of 1894.

Edmonton Public Library Online Catalog

http://www.publib.edmonton.ab.ca/

Expanding Universe

http://www.mtrl.toronto.on.ca/centres/bsd/astronomy/TERMS.HTM

A classified search tool for amateur astronomy. This website has been created in conjunction with LibraryNet, a cooperative venture of Canada's Libraries and Industry Canada.

Folklore and Mythology Electronic Texts

http://www.pitt.edu/~dash/folktexts.html

A wonderful, searchable collection of folk tales and myths. Edited and/or translated by D. L. Ashliman, University of Pittsburgh.

Genealogy Alberta

http://www.cadvision.com/traces/alta/alberta.html

Glenbow Museum

http://www.glenbow.org/museum.htm

Hudson's Bay Company Archives

http://www.gov.mb.ca/chc/archives/hbca/index.html

Index of Resources for History

http://www.ukans.edu/history/

This index is maintained jointly by the Department of History of the University of Kansas and the Lehrstuhl für Ältere deutsche Literaturwissenschaft der Universität Regensburg.

Lady Virgin Mary Flower Garden: Folklore Symbols

http://www.mgardens.org/

Mary's Gardens was founded in 1951 in Philadelphia, Pennsylvania, to research the hundreds of flowers named in medieval times as symbols of the life, mysteries, and privileges of the Blessed Virgin Mary, Mother of Jesus—as recorded by botanists, folklorists, and lexicographers.

Libraries on the Web

http://www.ipl.org/svcs/greatlibs/

The Internet Public Library is an educational initiative of the University of Michigan School of Information and is sponsored by Bell & Howell Information and Learning.

Library of Congress Home Page

http://www.loc.gov/

Métis Families

http://www.televar.com/~gmorin/

A wonderful resource for those people searching for their Métis roots, complete with fascinating folk tales and stories.

Microsoft Expedia Maps—Place Finder

http://www.expediamaps.com/PlaceFinder.asp

Microsoft's searchable map page is an invaluable resource for any armchair traveller.

National Archives of Canada

http://www.archives.ca/

Perseus Texts & Translations

http://www.perseus.tufts.edu/Texts.html

A veritable treasure trove of ancient texts and translations. The copyright to the Perseus database is owned by the Corporation for Public Broadcasting and the President and Fellows of Harvard College. The Yale University Press distributes the CD ROM version of Perseus.

Saskatchewan Cemetery Index

http://www.saskgenealogy.com/cemetery/cemetery.htm

Saskatchewan Genealogical Society's inventory of cemeteries. The database contains over 3150 cemetery and burial sites in the province.

Saskatchewan Towns and Cities

http://duke.usask.ca/~lowey/saskatchewan/cities/

This page contains information from various towns and cities within Saskatchewan.

Symbols in Christian Art and Architecture

http://www.fastlane.net/~wegast/symbols/symbols.htm

Walter Gast holds a Bachelor of Science in Education degree from Baylor University and a Master of Journalism degree from the University of North Texas. He is a certified secondary school teacher in the State of Texas. He currently teaches journalism and advises the scholastic newspaper and yearbook programs at J.J. Pearce High School in the Richardson Independent School District. Walter is an elder in the Presbyterian Church (USA).

Tombstone Tourist

http://www.teleport.com/~stanton/

The final resting places and shrines of musicians, actors, artists, and authors, with links to a wildly eclectic assortment of websites presenting funerary art. A site by Scott Stanton: aka The Tombstone Tourist.

INDEX

In this index, numbers appearing in bold indicate a photograph.